YSTAL PALACE.

CE

13

12
L

13

14

15

16

29

GENTLEMEN LADIES

REFRESHMENTS

LADIES.

17

ENTRANCE.

FOUNTAINS.

22

21

20

19

18

OPEN CORRIDOR.

OPEN CORRIDOR

QUEENS
APARTMENTS

R. GLAZED CORRIDOR.

THE PARK.

CARRIAGE ENTRANCE.

NORTH WING.

RAW MATERIAL & AGRICULTURAL IMPLEMENTS

DBURY & EVANS, II. BOUVERIE ST. P.H. DELA MOTTE.

DELAMOTTE'S CRYSTAL PALACE

PLATE XL

Persian ornament
from Owen Jones's
*The Grammar of
Ornament*, 1856.

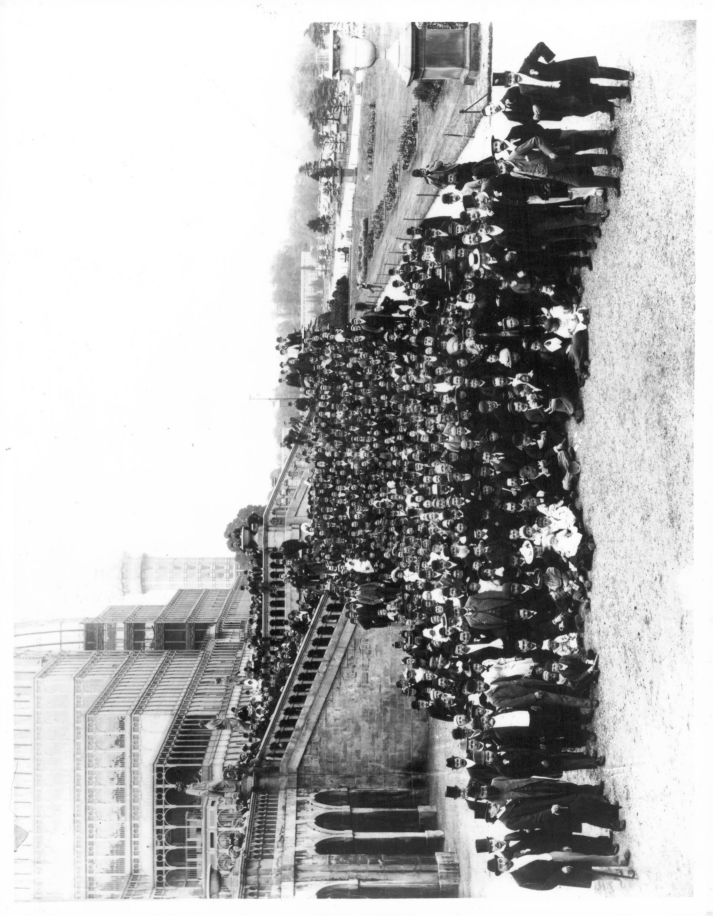

DELAMOTTE'S

Crystal Palace

A Victorian pleasure dome revealed

Ian Leith

Published by English Heritage, Kemble Drive, Swindon SN2 2GZ

Copyright © Ian Leith, 2005
First published October 2005

The right of Ian Leith to be identified as the author of this work has been
asserted by him in accordance with the Copyright, Designs and Patents
Act 1988.

Product code 51074
ISBN 1 85074 949 3

A CIP catalogue for this book is available from the British Library.

English Heritage is the Government's statutory adviser on the historic
environment.

Edited by Katy Carter
Brought to press by Adèle Campbell, English Heritage Publishing
Designed by George Hammond
Printed by Bath Press

Front cover: Images from the Delamotte collection,
© Crown copyright. NMR.

Back cover: Dufaycolour print of the Egyptian Court, 1936, by
Arthur Talbot. Fewer than 10 colour views of of the interior of the
Crystal Palace are known to exist. Arthur Talbot was a south London
photographer who was associated with the Crystal Palace, which may
have supported his experimental use of early colour processes.
© Crystal Palace Museum.

Front endpapers: Plan by Delamotte, from the *Guide to the Crystal Palace
and Park,* by Samuel Phillips,1854.

Back endpapers: Plan by Delamotte, from *Geology and Inhabitants of the
Ancient World,* by Richard Owen,1854.

Contents

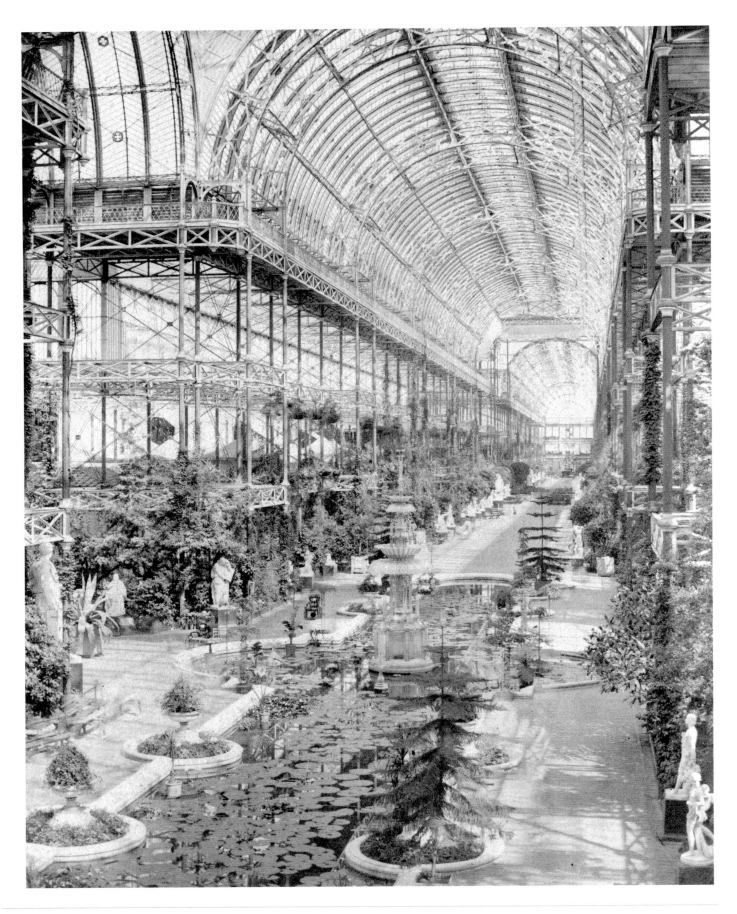

Introduction

Look attentively at my elegance, thou wilt reap the benefit of a commentary on decoration.

For, by Allah! the elegant buildings by which I am surrounded surpass all other buildings in the propitious omen attending their foundation. Apartments are there enfolding so many wonders, that the eyes of the spectator remain for ever fixed upon them; provided he be gifted with a mind to estimate them.

How many delightful prospects – how many objects in the contemplation of which a highly gifted mind finds the gratification of its utmost wishes. Markets they are where those provided with money are paid in beauty, and where the judge of elegance is perpetually sitting to pronounce sentence. This is a palace of transparent crystal; those who look at it imagine it to be a boundless ocean

Indeed we never saw a palace more lofty than this in its exterior, or more brilliantly decorated in its interior, or having more extensive apartments. And yet I am not alone to be wondered at, for I overlook in astonishment a garden, the like of which no human eyes ever saw.

Verses on the walls of the Hall of the Two Sisters in the Alhambra forming part of a poem in honour of its builder, the Iman Ibn Nasr, quoted by Owen Jones in The Alhambra Court in the Crystal Palace, *London 1854*

I<small>N JULY 2004 ENGLISH HERITAGE</small> was alerted to the forthcoming sale by auction of a portfolio of 47 photographic prints by Philip Henry Delamotte entitled *The Crystal Palace at Sydenham*. An initial check with other archives established that this set was unique in Britain, and with the aid of the Crystal Palace Foundation and the London Development Agency, the portfolio, previously in private hands, was purchased by English Heritage in August 2004. After conservation and study, it has become clear that these later images are the first set to show one of the most important buildings in England at the height of its fame, in the late 1850s. Although some of the individual images from this set were already known, they were mostly confused with the similar views taken by the same photographer, which showed the palace while it was under construction. Delamotte had also photographed the opening of the palace at Sydenham by Queen Victoria in June 1854.

The first Crystal Palace had been built to house the Great Exhibition, the brainchild of Prince Albert, which opened in Hyde Park on 1 May 1851. The exhibition was a huge success, and after it closed there was much debate about the future of the extraordinary Crystal Palace, an inspired design by Joseph Paxton partly based on his building of the great glasshouses at Chatsworth. Designed to be dismantled, it was purchased by the Crystal Palace Company who had identified the site in Sydenham in Kent because of its easy railway access to the capital. There it was re-erected in 1854, but not as a duplicate of the original. This new palace took 23 months to build and used twice the glass of its predecessor. At 1608ft long and 315ft wide it was shorter than the Hyde Park palace but its central transept was wider and, at 108ft, was 44ft higher. In its new location the palace quickly became an established popular resort for Londoners and the nation, attracting about two million visitors a year during its first 30 years. The subsequent history of the palace is well known: despite a serious fire in 1866, the palace survived for another 70 years, until it was destroyed by a spectacular fire on the night of 30 November 1936.

This book explores the Crystal Palace at Sydenham while it was at the height of its fame,

Nave from the south
Delamotte c.1859.
The extreme length [1608 feet] is broken up by the foliage, statuary and the transepts but without the colour scheme by Owen Jones the eye could not grasp any divisions at all given the amount of light. The Osler Fountain in the nearest pool was one of the few items transferred from the first palace. Compare with plate on p15.
[DP004606]

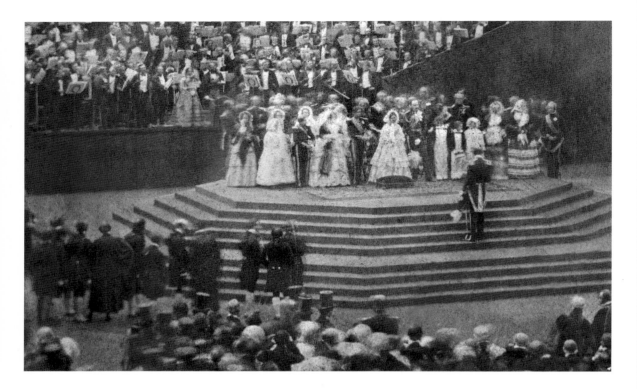

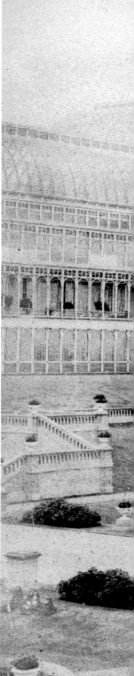

Opening of the Crystal Palace by Queen Victoria
Probably by Delamotte, 1854.
A detail or cropped version of a view captured by Delamotte and other photographers showing Queen Victoria at the centre of a dais filled with officials receiving the directors of the Crystal Palace Company, including Joseph Paxton and Owen Jones. The technical problems associated with recording such a live event were considerable: this is the first known 'news' photograph in the world.
[AL/00327]

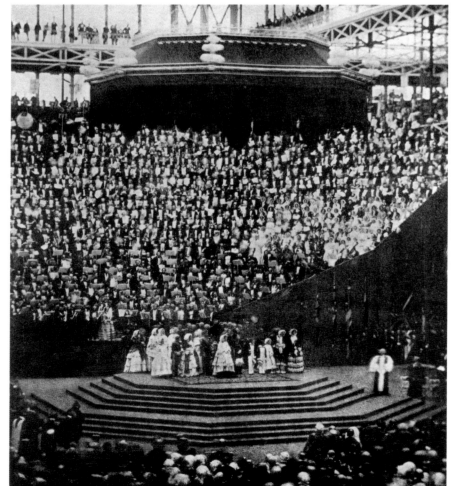

Opening of the Crystal Palace by Queen Victoria
A 1910 engraving from an original, possibly by Delamotte.
[SC/00710]

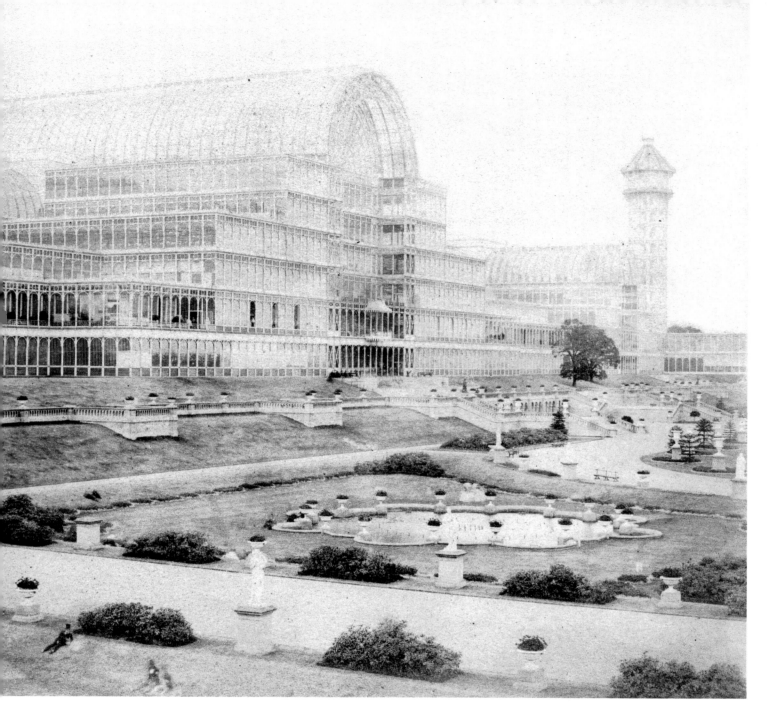

through the newly acquired set of Delamotte photographs and through other contemporary images. Many of the images shown here, including Delamotte's, depict the palace before some of its features were destroyed in the fire of 1866. The discovery of the photographs also provides an opportunity to examine the roles of some of the individuals associated with the palace. In particular Joseph Paxton, the architect of both palaces, who had previously been better known as a landscape gardener, and Owen Jones, a well known architect who had been superintendent of works for the 1851 Exhibition. Jones became one of the key designers after the move to Sydenham, where he was involved in selecting the artworks to be displayed and in designing the new Greek, Roman, Egyptian, and Alhambra courts.

The Delamotte collection also shows how the history of the palace is bound up with the history of early photography. Philip Henry Delamotte himself was closely associated with the palace at Sydenham for at least eight years, and his work

The Upper Terrace from the south east
Delamotte c.1859.
The gardens closest to the palace show the formal layout of sculpture, planting and pools. In the 1950s much of the outdoor sculpture and hundreds of urns were sold by the LCC.
[DP004601]

second Crystal Palace yet known, provide an opportunity to re-examine its significance. In particular they give us a sense of the scale of the building, and quite clearly indicate that the Sydenham palace should be considered in its own right and not as some inferior adjunct to the Great Exhibition. The palace in Hyde Park housed a unique international event that lasted eight months; the palace at Sydenham was a cultural phenomenon that endured for more than 80 years. But in order to understand the pleasure dome which was the Crystal Palace we need to look carefully at these photographs – both at the images themselves and at our presumptions about what they reveal and ignore.

as a whole deserves to be reviewed. In common with his more famous colleague, Roger Fenton (1819–69), he was a pioneering photographer and among the first to define our knowledge of England through the new medium. He also had considerable influence on the early development of photography in Britain. His photographs of the Crystal Palace date from a critical period in this development; although photography was first invented in 1839, it was not until the early 1850s that much of its potential was actually realised. The Crystal Palace in both incarnations therefore stood at the precise time when photography was beginning to affect our way of seeing the world.

Much was lost in the fire of 1936 beyond the actual structure of the second Crystal Palace. Although we know that it received tens of millions of visitors, we have difficulty today in understanding the idealism behind the second palace, which was frequently disparaged as just a giant greenhouse, created by a gardener and notable only for of its size. It has always existed in the shadow of its predecessor but the recent work of Jan Piggott has enabled us to see that it was much more than just the aftermath of the Great Exhibition – it was one of the most confident of all Victorian projects. Delamotte's newly discovered photographs, the best images of the

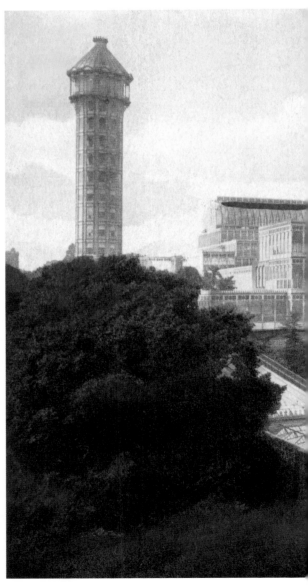

Some of Delamotte's new images have been used to illustrate the opening sections of the book (indicated by their scan number, prefixed DP, at the end of the caption), which describe the importance of the palace, its connection to the development of photography and some of the key figures associated with it. The majority of the collection is reproduced in the second half of the book, and is organised as a visual tour through the various parts of the palace the photographs depict.

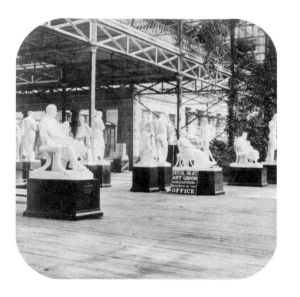

Entrance to Greek and Roman Sculpture Courts
Anon: stereo c.1860.
Note the sign 'Crystal Palace Art Union Subscriptions Received' leaning against one of the plinths – the main set of Delamottes are all inscribed 'Crystal Palace Art Union'. The Union helped to stimulate public taste: in exchange for subscriptions it provided members with prizes which included small sets of the Delamotte images published in this book as well as others by Roger Fenton. [BB83/03183b]

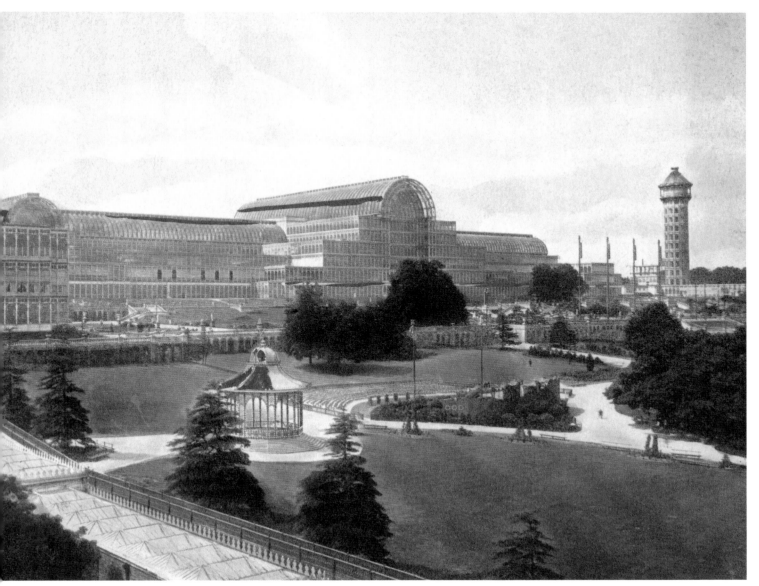

South end of the Nave, 1936
Dufaycolour print by Arthur Talbot.
Even though the Dufay process was not as faithful as those being developed by Kodak and Agfa at the same time, we do get some idea of the festive décor inside the palace.
[© Crystal Palace Museum]

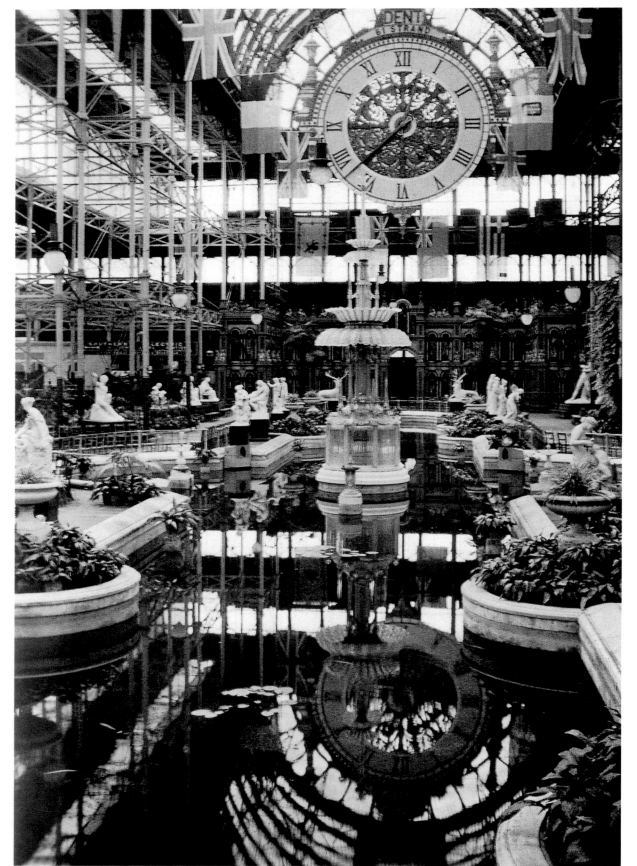

The Two Palaces: Invisible Symbols

THE TWO CRYSTAL PALACES have received so many eulogies and at the same time been so misunderstood that we need to examine contemporary and subsequent comments and assumptions carefully in order fully to understand what the palaces represented, both to contemporaries and to subsequent generations. The vastness of the great glasshouses and the subsequent dispersal or destruction of both the site at Sydenham and its contents have generated a curious aura of myth and fiction. Various authorities and commentators have tended to use the idea of the palace as the palace itself was used: as a vehicle for whatever they wished to express or display – which may have little or nothing to do with the real purpose of the palace or how it was perceived by the public.

The first Crystal Palace, created for the Great Exhibition of all Nations in 1851, was the precursor of the 1854 Sydenham palace, but the two have often been confused. Though both were great landmarks both palaces were much criticised before and after they were built and even after they were destroyed. When the Albert Hall was being built in 1870, for example, a contributor to *The Builder* hoped that it would not be modelled on the structure that had once stood across the way in Hyde Park: 'Anything approaching the endless and unrelieved parallelograms of the Crystal Palace will entirely ruin the building.' Contemporary critics of both structures were formidable, and included William Morris, Augustus Pugin and John Ruskin, all of whom vociferously denigrated both palaces. The effective use of modern materials, the dominance of engineering and the machine-made contents of the palace were

'A View of the Great Exhibition in Hyde Park'
Engraving by George Virtue 1851.
The Hyde Park Crystal Palace was longer and lower than the version erected in Sydenham which had a much greater volume. Very few photographs exist to give the landscape context in Hyde Park – the extreme length and prefabricated simplicity are evident only from drawings or engravings.
[BB58/322]

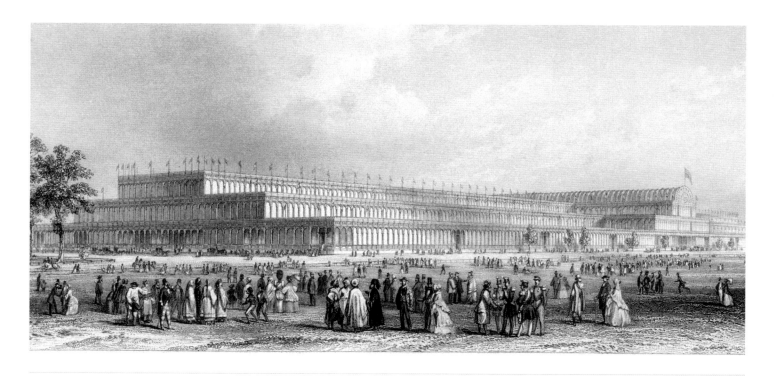

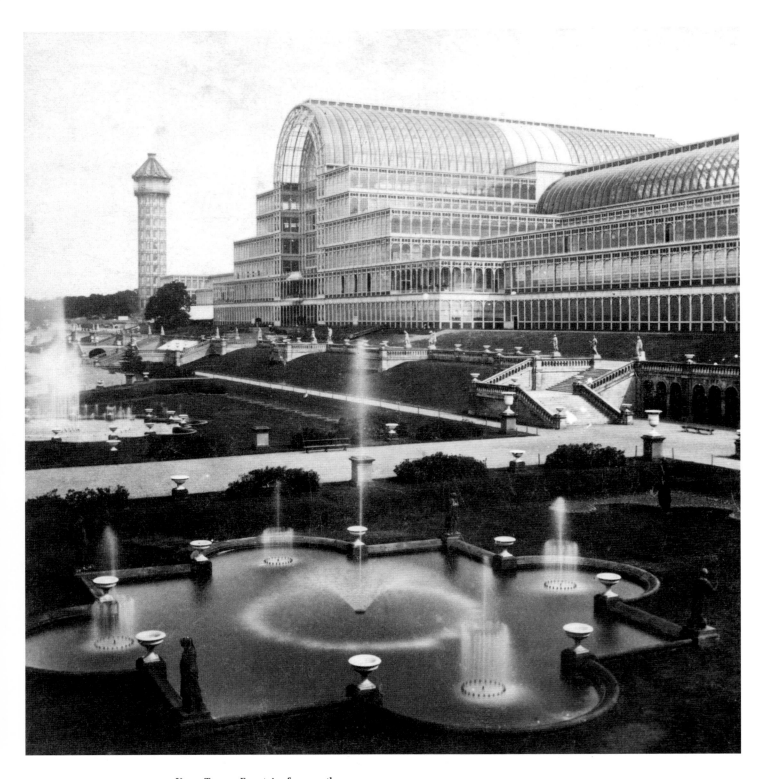

Upper Terrace Fountains from north
Anon: stereo c.1860.
The smaller series of fountains closest to the
palace survived longer than the main jets
because they were easier to maintain.
[BB83/3194]

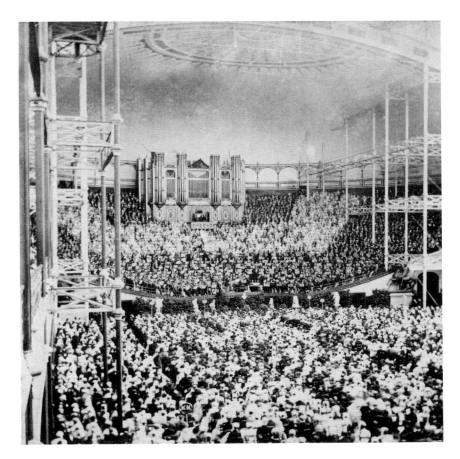

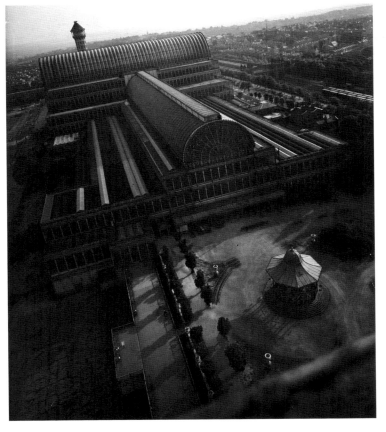

despised and feared as evidence of the domination of 'trade' and of the loss of traditional artistic values.

Much of the criticism was focused on Sir Joseph Paxton. At the time he was seen as a landscape designer, an expert in horticultural structures and what we would now call a master-planner – but quite clearly not as an architect. A number of quite notable architects had been unable to produce a viable design for the 1851 Exhibition: they and their peers never forgave Paxton for coming to the rescue at such short notice in Hyde Park and it took many decades before architects could come to terms with the permanent glass icon in south London. It is ironic that the fire of 1936 was the stimulus that brought full acknowledgment of this achievement.

Yet despite the critics, the immense spaces of the second Crystal Palace became home to a variety of cultural events which has seldom been emulated anywhere else. It had a staggering impact on many disciplines, entertainments, commodities and arts. In literature it had a disturbing effect on Ruskin, Dostoyevsky, Dickens and Turgenev. In music it was the first popular venue for classical music; a distinction often credited to the Albert Hall. Sydenham attracted such key musicians as Berlioz, Bruckner and

Below right:
Vaulted passage between High Level Station and the Crystal Palace
© Michael Evans, 1988.
The elaborate columned and tiled connection between the second railway station and the palace was built in 1865 and is one of the very few structures which still remains today. It is not currently accessible but is designated a listed building.

Low Level Station
Anon: stereo c.1860.
The Low Level Station was damaged during World War II but is still in operation as Crystal Palace station. Built in 1854, it was insufficient to cope with the demand so the much bigger and more convenient High Level Station was built in 1865. Two railway stations with at least six lines provided short shuttle services from many parts of central London. The Crystal Palace Company directors came from a railway background and effectively created the first mass transit system for a permanent theme park, which involved major engineering works.
[BB88/2290]

Dvořák. The huge structure was suffused with light, and was the stage for an unimaginable series of displays and events; ultimately it attained an almost fictional or fairy-tale status which was alluded to by many commentators, including Dickens. This was indeed a fresh space, which proved that industrial Britain was not only represented by dark Satanic mills.

The engineers, designers and railway businessmen who conceived the second Crystal Palace were the foremost men of their time and theirs was a venture of such magnitude and risk that it could only have been realised during the Victorian era. Apart from boosting British 'arts and manufactures' the Great Exhibition was intended to stimulate and educate British consumer taste, which was perceived to be lagging behind that of France and other burgeoning industrial economies. Such was its success that thoughts soon turned to finding a suitable reuse for the palace itself, resulting in the formation of the Crystal Palace Company in 1851. Most of those involved in the design and construction of the Hyde Park palace were involved in the Company (with the exception of Prince Albert who, together with the Royal Society of Arts, had been a staunch supporter of the original project). The Crystal Palace Company then bought the structure; it continued to charge for entry until its financial collapse around 1911 then in 1913 the whole complex was 'saved for the nation' and became public property.

The palace at Sydenham was therefore a private enterprise, though the Crystal Palace Company was run like a cross between a business and a museum. It inherited much of the dynamism and idealism of the Great Exhibition and Paxton's intention was to create a new kind of permanent attraction that provided cultural attractions as well as making money. One of the first company directors was Charles Grove; also an engineer but rather better known as the creator of the definitive dictionary of music and the promoter of what was to become the greatest musical venue in London. One of many the fascinations of the Crystal Palace is the involvement of such diverse talents and personalities, reflected in the diversity of events it hosted.

Though no long-term plan had been made for the Hyde Park palace, Paxton had designed it as a temporary structure and his pioneering prefabrication allowed the transfer of many original components to the new building. Paxton seized the opportunity to develop a new structure designed to last, using the latest industrial technology. This second and arguably greater palace was bigger in volume and taller than the first though not as long. It was set in a newly created park in picturesque South London (one of the reasons for its removal from Hyde Park was the controversial setting of such an uncompromisingly modern structure in a royal park).

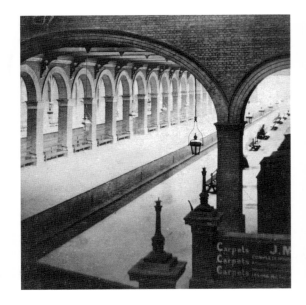
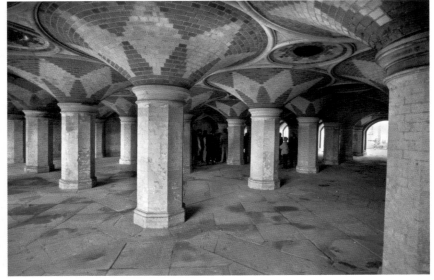

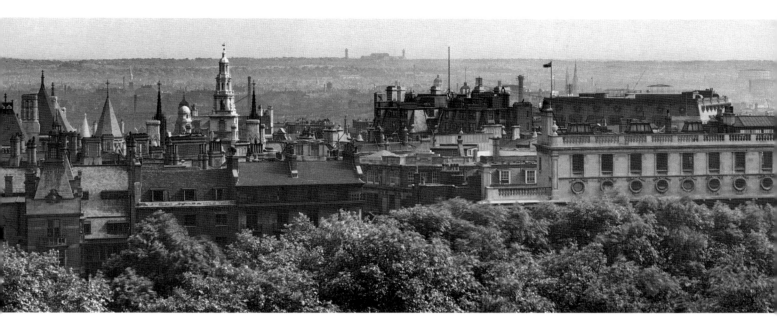

In 1854 the Crystal Palace was situated beyond built-up London; Sydenham was more a part of rural Kent than a suburb and only this undeveloped land could provide the amount of open space necessary for a structure. The development of the railway and the access provided by two major stations (Crystal Palace High Level and Low Level) enabled tens of millions of visitors to come and marvel at the simplicity and scale of this palace of culture. Special trains and fares brought them from all parts of London. Despite frequent comments that the palace was too far from the capital, in the early years it nevertheless attracted more visitors than central London's two main attractions – the British Museum and the Tower of London – put together. Foreign visitors in particular were almost universal in their praise. A notable exception was the eminent French historian Hippolyte Taine, who like many was impressed by the scale but considered the Sydenham palace to be 'a kind of museum' with an 'agglomeration of incongruous curiosities', although even he was much attracted to the surroundings.

It is very difficult to imagine all this today, standing in an ordinary suburban park in the London Borough of Bromley. The park now has almost no visible link with the images portrayed in the following pages – only the surreal prehistoric animals and a few terraces survive as clues to its past. It is a signal omission that a nation so

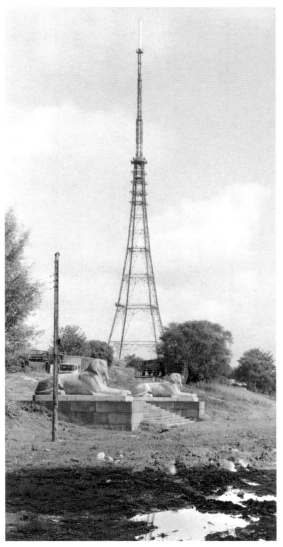

Distant view from west
Bedford Lemere, 1920.
The palace is clearly visible on the South London horizon. This photograph was taken from a roof in Lincoln's Inn Fields: Sydenham is over 5 miles away. Despite the existence of telephoto lenses by 1936 the number of known panoramic views that exist to show the domination of this structure is extraordinarily small. Other views will almost certainly be found in the future.
[BL25009/4]

Remains of the Crystal Palace Park
Paul Barkshire, 1983
Today even the sphinxes have gone leaving only the 1955 TV mast as a marker for the whole palace complex.
[DD88/315]

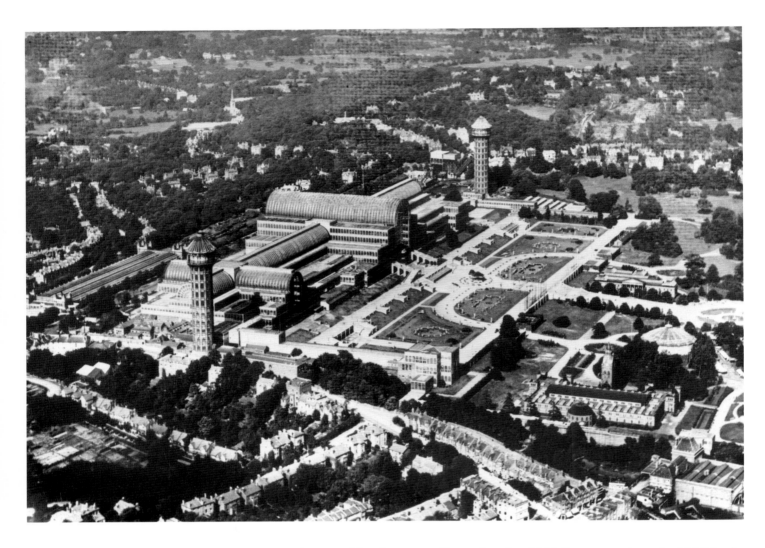

Aerial view of Crystal Palace
R H Windsor c.1935.
[RHW TQ3470/3 11521 A2389]

devoted to gardens, plants and landscape could allow such a historic landscape to be neglected. During and after World War II the entire site was used as a dumping ground for rubble from demolished buildings; it was also later used as a giant automobile graveyard and a meeting place for the Caravan Club. The existence of the National Sports Centre in the middle of this park is telling evidence of how English taste can mutate: one hundred years after Paxton's greatest landscape setting was created, the jewel at its heart is missing and even the derivation of the name Crystal Palace risks falling into obscurity. This lack of care for the landscape reflects how, in many ways, the second palace and what it symbolised have been neglected over the years.

Many architects of the Modern Movement, however, saw the second palace in a positive light. The most famous obituary of the building

after the 1936 fire was written in 1937 by Le Corbusier in the *Architectural Review*: he was quite clear that what had disappeared with the fire:

> '*was not a curiosity, but one of the great monuments of nineteenth-century architecture … By some miracle the Crystal Palace still remained as a last witness of that era of faith and daring. One could go and see it, and feel there how far we have still to go before we can hope to recover that sense of scale which animated our predecessors in all they wrought.*'

If the Crystal Palace had survived it might have become a national icon, much as the Eiffel Tower did in France. British architects, while taking full advantage of the advances that had been made in the use of iron and glass, preferred to hide such functional materials behind a bewildering range

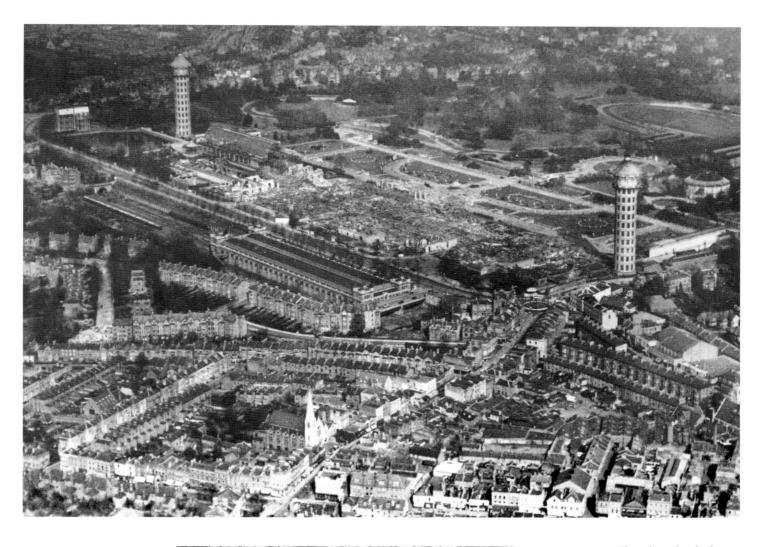

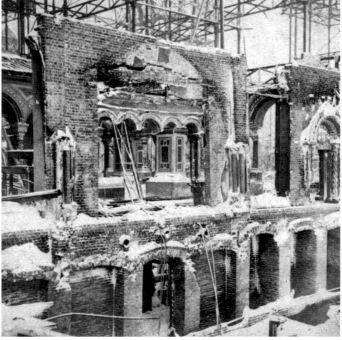

The palace after the fire
R H Windsor, 1936.
*[RHW TQ3470/4 11521
H6133]*

North end of Garden Front
Anon: stereo 1866.
*The seriousness of the 1866
fire is evident from the
extensive damage to many
of the Fine Arts Courts.*
[BB92/15895]

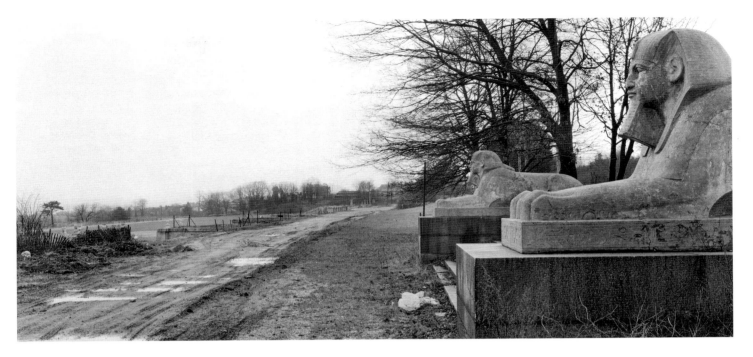

of historical fronts. In France it was different: after the Crystal Palace these ferro-vitreous materials became hugely popular, not just for exhibitions but for libraries, markets and other public buildings. This culminated in the Eiffel Tower, built in 1889, which also had to endure severe criticism before it eventually became a symbol of the city of Paris.

The spirit and energy of the 1850s saw many great engineering projects come to fruition in England, including the construction of the steamship *Great Eastern*, the railways and their

stations, and the Victoria Embankment. It was this spirit which allowed the Crystal Palace to be built, reconstructed and used, and which could also foster a palace of culture never since matched in its scope. Such vision and energy appear now to have been lost: the only modern equivalent of the palace, the Millennium Dome, failed to provide a comparable pleasure dome for London. A similar lack of imaginative risk-taking characterised the Festival of Britain in 1951. Apart from the Festival Hall, all the buildings of the 1951 exhibition on the South Bank of the Thames were removed in a manner reminiscent of 1851, but none of the exhibition structures was made available for other locations even though many bombed sites in urban areas were available across Britain and remained empty for decades afterwards. The content of the 1951 exhibition similarly lacked the scope and vision of the Crystal Palace. As Charles Plouviez, one of those closely associated with the Festival of Britain, wrote: 'Where 1851 had been deliberately international, 1951 was deliberately chauvinistic. It might almost be said to mark the beginning of our "English disease" – the moment at which we stopped trying to lead the world as an industrial power, and started being the world's entertainers, coaxing tourists to laugh at our eccentricities, marvel at our traditions and

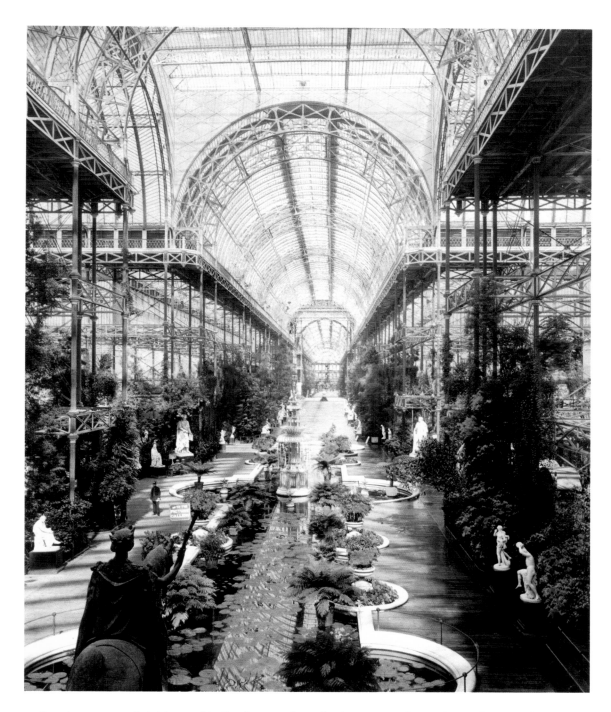

Nave from the south
One of four hand-tinted photographs that may have been taken by Delamotte, c.1860. See also pp 32–3.
[FF91/334]

wallow in our nostalgia' (quoted in Banham and Hillier 1976, 166).

There was no nostalgia at the Crystal Palace in Sydenham. It was a dynamic cultural force expressing the ambitions and taste of a period which ought to be described as 'Albertian', since its ethos was quite distinct from the High Victorian spirit which prevailed after Prince Albert's death in 1861. In mourning him Queen Victoria herself helped to create the nostalgia of the heritage industry by enshrining the virtues of her husband. The Albert Memorial and the national triumph of the Gothic were not inevitable to those trying to educate taste in the mid-1850s. The loss of Prince Albert was felt well beyond the royal household: the whole country had lost a champion of innovation and taste. We have also lost two versions of one of his most important initiatives: the Crystal Palace in Hyde Park and the Crystal Palace at Sydenham.

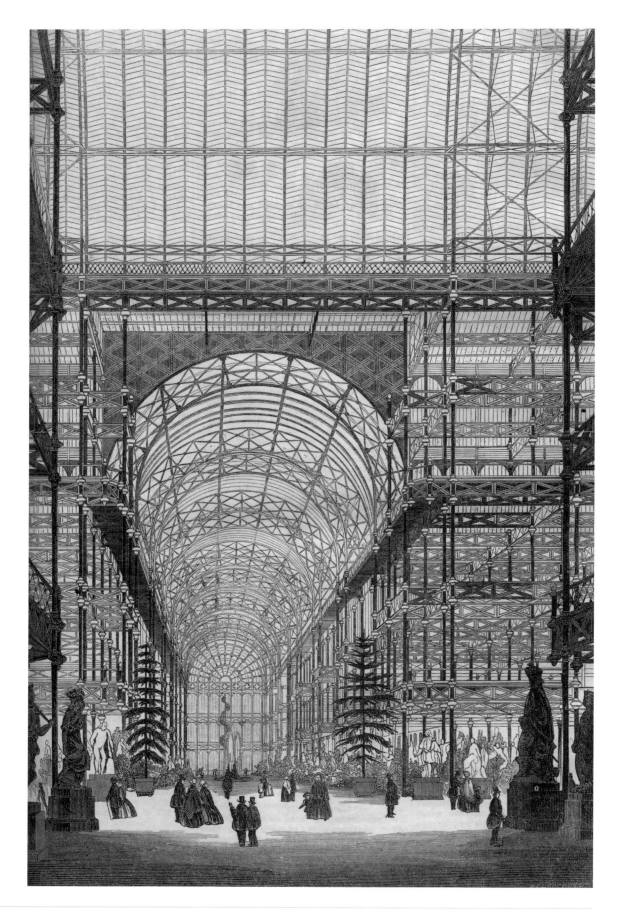

Engraving of the interior
The Builder, June 10, 1854.
*Line drawings, engravings
and lithographs were
artistically attractive but
introduced elements of
inaccuracy or even invention.*

The Palace and Photography

HE FIRST PALACE IN HYDE PARK failed to present the potential of photography adequately; many photographic displays were hidden away and often lost in the vast displays of other technological innovations. In 1851 the daguerreotype was still the predominant photographic process but this earliest type of photograph could not be reproduced – the daguerreotype was a unique image. Popular photographic reproductions did not therefore exist: for more than a decade after 1839 the only way to commercially exploit the new medium was to create line engravings based on photographs. Despite more than ten years of development, photography was still in its infancy in 1851, so actual photographic evidence of the interior and exterior of the first palace is extremely rare.

By 1854, however, photography had finally come of age in Britain, so the real dawn of the medium coincided with the second Crystal Palace. This put an end to the predominance of French and American photography that had prevailed at the Great Exhibition of 1851. New and robust negative techniques had now evolved to the point where multiple photographic prints had become possible, though they were still very expensive; this allowed the second palace itself to be photographically explored in new ways.

The Crystal Palace Company consciously employed the new medium to its best advantage to attract visitors. This use of photography pioneered a new form of mass communication, just as the railways could transport a new mass audience; this was spectacle on a gargantuan scale, and images of the palace were seen across the world. By 1858 Sydenham contained the first large display of photographs to be presented to the public in England beyond short-term exhibitions. This commitment to photography gave a much broader spectrum of visitors the chance to appreciate the great appeal of this new medium, particularly its ability both to record information accurately and to capture the spirit of a place. Delamotte's reputation was founded on his commission to document the building and its fitting-out at Sydenham, which work appeared in his *Photographic Views of the Progress of the Crystal Palace, Sydenham* (1855), but this famous set of 160 views did not show the vast complex in operation. Delamotte's subsequent and equally magnificent record of the palace after its opening and during its mature phase is represented in this newly rediscovered collection, reproduced for the first time here.

Even though by the mid-1850s it had become much easier to generate images and, by the 1860s, to reproduce them industrially and cheaply, there is a curious shortage of photographs in publications about Sydenham. Nearly all contemporary publications depended on colourful, non-photographic illustrations, simply because it was so almost impossible at the time to reproduce photographs successfully. Later in the century, when a vast number of photographs were available, most of the views printed were conventional ones. But the spate of publications which appeared after the fire of 1936 persisted in using engravings, as though photographs continued to be 'tainted' with trade associations; where photographs were used, they were rarely given the same level of attention as other artistic forms of illustration and photographers were seldom credited. Paradoxically, photographs of the first palace have become valued for their rarity – photographs by Fox Talbot and a few others are now given due acknowledgement precisely because of the technical difficulties they overcame to take such images and these photographs

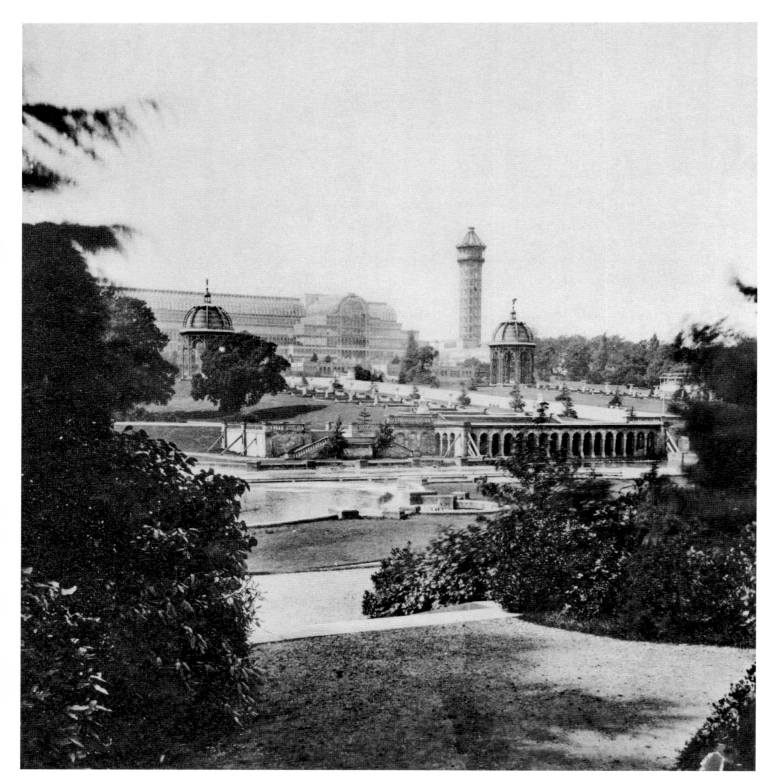

Gardens, Cascade and North Tower
Anon: stereo before 1866.
See Delamotte plate p58 and his
lithograph p31 – the latter omits the
water tower. Most of the north end was
destroyed in the 1866 fire.
[BB81/7416a]

have now become part of photographic history. Later images, by contrast, are so numerous that we are overwhelmed by apparently overlapping and proliferating visual evidence. This proliferation of photographs can cause a distortion of our usual faculties of discrimination, but the ease with which millions of prints could be created, purchased and put in the family album should not obscure the fact that real historical gems remain to be discovered. The Crystal Palace is a case in point: with careful examination, the mountain of images of this non-existent site can enable us to distinguish salient facts from convention, myth and distortion.

Fortunately for us, Delamotte's photographic record of the construction, opening and continuing use of the Crystal Palace at Sydenham took place at a time when the dynamic new breed of Victorian engineers and entrepreneurs were using photography as a tool for documenting and publicising the progress of many of their great projects. These pioneers were still adapting to a fresh medium as well as reacting to these projects and to history (in the Crimea Roger Fenton was making the first photographic record of war). Without Delamotte, Fenton and others our ability to comprehend the period between 1854 and 1866 – when the second palace was at the height of its fame – would be entirely dependent on pre-industrial 18th-century media: drawings, plans, sketches, engravings, lithographs and paintings.

As with any art form, however, the photographic 'evidence' warrants careful investigation for several reasons. It must be remembered that the images that survive today are only a tiny minority of those that must have been taken; those that do survive have been subjected to a ruthless and largely commercial process of selection, often unconnected with the reasons the photographs were taken over 150 years ago. Many more images undoubtedly remain to be discovered in so far unexcavated archives that could reveal a wealth of detail about the period from 1839 until the 1860s when photography was still in its infancy.

Many aspects of the palace were accidentally or deliberately ignored by the camera for reasons of commerce and taste. Among the material so far discovered, we have almost no views of the commercial heart of the Crystal Palace (see Appendix for the 1854 List of Exhibitors); we do not see the machinery and manufacturing processes that were sited in the building. We also have very little idea how people interacted with the spectacle of

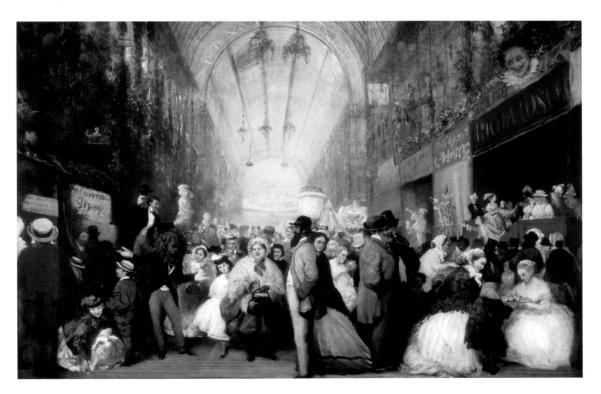

Painting of the interior
A Blaikley, 1866.
In spite of the fact that photographs would have been quite feasible after the 1860s and the fact that there were over 100 million visitors during its 80-year existence finding images of the palace, which reflect such popular enjoyment can be quite difficult: something of this atmosphere is conveyed by the bustle of the Royal Dramatic College Grand Fete and Fancy Fair, 1863.
[© James & Patricia Ritzenberg]

the palace and its displays, which attracted over 100 million visitors over a period of 80 years. These visitors, in common with most of the attractions they enjoyed, remain largely invisible. There are also very few photographs taken for purely artistic reasons. Émile Zola, who lived in London near the Crystal Palace, is one of the few known to have taken artistic images in the area; there seems to have been little to inspire the art photographers of the Pictorial movement to produce soft-focus impressions of this London fixture between 1890 and 1914. By 1914 Sydenham had become a people's palace which did not attract those with photographic pretensions.

General exterior and interior views of the second palace therefore tend to duplicate conventional views, while often ignoring the things we would now like to see, such as visitors and events. Many images present only a veneer, since so much is absent from them. The visual definition of the structure and the grounds of the palace is only superficial and was almost exclusively taken for commercial or publicity purposes. Any photographs taken before the fire of 1866 are now extremely rare.

Despite the fact that no image is yet known of the important display of photographs in the upper gallery at Sydenham, including Delamotte's, indirect views of it may yet be found. The significant absence of photographic records of all forms of exhibition at this gallery level is in notable contrast to the wealth of images of the stupendous views at ground level. Superb views were taken for the Crystal Palace Company and the Art Union, but presumably very few commercial or institutional sponsors were willing to commission views of these more practical items. So the corridors and upper galleries which intrigue us now were not photographed because they did not possess either commercial or artistic value for the photographer. However, at least one view shows that exhibitions of framed images did indeed appear at ground level: these could perhaps have been photographs (p87).

Delamotte avoids showing major physical elements which would have interfered with his vistas but would have been clearly visible to any observer at ground level. As a result, there are no views of the great Handel orchestra in the central transept, which later became a permanent feature, and there is no evidence of what *The Times*

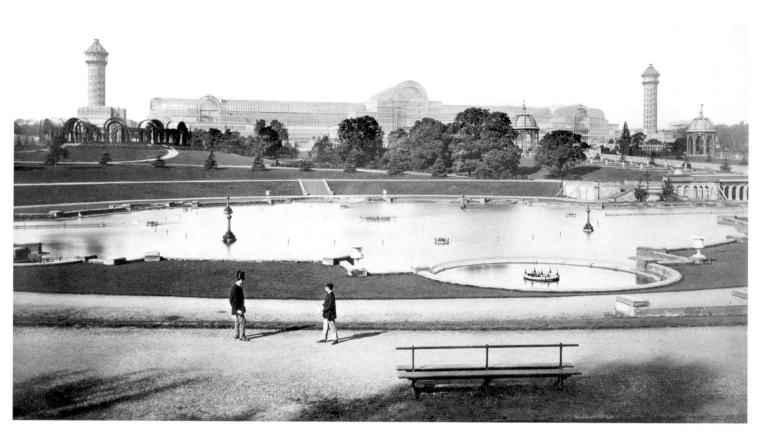

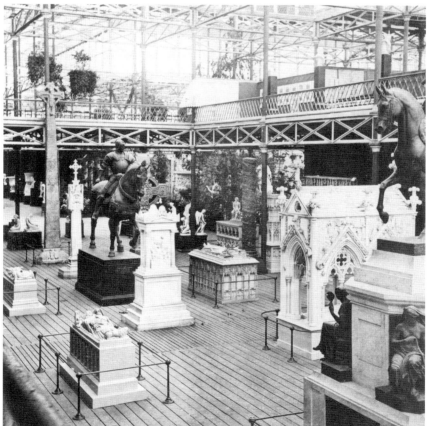

Above:

Distant view from east
Anon via G Stamp: before 1866.
The full extent of the pre-fire palace is seen behind the giant lower fountain basins which later became a football ground and then part of a motor racing track in the 1950s.
[BB83/4791]

Left:

Court of Christian Art from the Gallery
Copies of antique equestrian statues were included with a reduced copy of Trajan's Column and much other classical sculpture. Only a few of the many casts were transferred to the Victoria and Albert Museum before the 1936 fire. Note the exhibition in the gallery above, which could be paintings or possibly photographs.
[BB69/1079a]

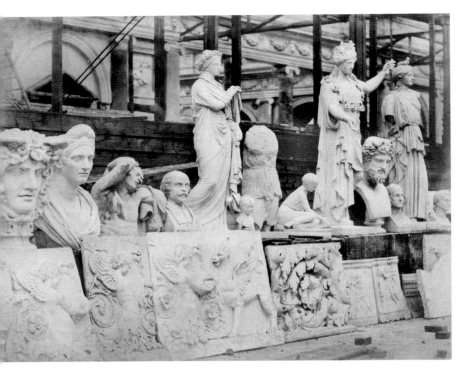

Sculpture and reliefs before the opening of 1854
Delamotte 1853/4.
Delamotte made his first series of photographs during the construction and fitting-out of June 1854. Here he captures the amazing variety of casts and reliefs before they were finally put in place.
[AL/00327]

Detail of sculptures
Delamotte 1853/4.
[AL/00327]

described on 29 September 1856 as the 'rather unsightly canvas partition necessary to the maintenance of a proper temperature [for] the exhibition of tropical plants'. Like all photographers Delamotte quite consciously chose his viewpoints to maximise the effect he sought in his work. In his carefully staged photographs taken from very carefully selected viewpoints there is no clue to the fact that there were hundreds of stalls, showrooms and trade exhibitions at ground and gallery levels. Yet it is quite clear from documentary evidence (see Appendix) that the palace was literally a bazaar. People went to the palace to shop as well as to be entertained and educated. There is also a complete absence of anything showing the very extensive refreshment facilities. These were so developed that an entire leaflet was produced later in the century describing the kitchens near the south transept as the 'Culinary Court', and providing numerous statistics: there were a 'quarter of a million plates and 8,000 dishes, 10,000 forks and spoons, 20,000 knives, 4,000 carafes, 18,000 wine, champagne, hock, and claret glasses', all of which were washed in a scullery amusingly called the 'Ceramic Washing Court' and supplied from a cellar containing 10,000 dozen bottles of wine. Mineral and soda water were produced on site for consumption of up to 6,000 bottles per day from the artesian well in the Crystal Palace Park. The most expensive champagne cost 12 shillings, while bread and cheese could be enjoyed for 3 pence.

So, despite the apparent wealth of early images, we should be aware that neither Delamotte nor any other photographer was attempting to create what we might consider an 'objective record'. They were taking photographs purely for aesthetic or financial reasons, so images of many parts of the Crystal Palace are very difficult to find. This focus on the aesthetic or commercial is not just Victorian: the creation of many images today is still driven by incentives which do not necessarily result in the widest possible coverage. What we consider uninteresting or irrelevant today might be the very aspects that historians of the future consider the most important.

There are various reasons why photographic records are unlikely to provide an objective or full

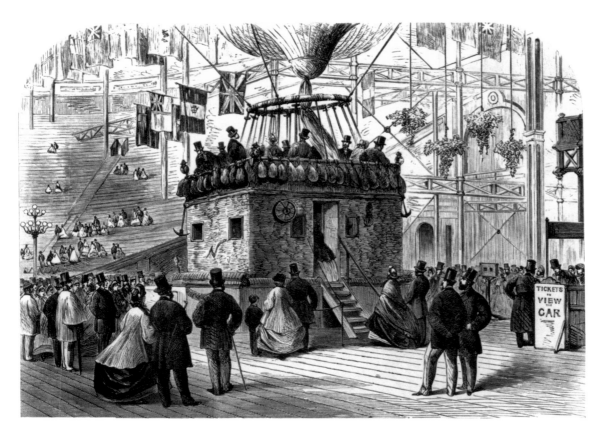

Nadar's balloon 1863
The huge basket of pioneer French balloonist and photographer Nadar was displayed inside the palace in 1863. Some idea of the scale is evident from the people atop and inside the massive basket. This 1910 engraving almost certainly derives from a photograph, possibly by Negretti. For the balloon itself see p51.
[SC/00710]

record. First, many types of building, particularly commercial premises, are rarely photographed: very few photographic records exist, for example, of interiors of the thousands of public houses in Britain. Second, many images are lost or destroyed. The resurfacing after 150 years of an unknown set of images of a key structure suggests we should take more care of this visual wealth. Third, photographic collections are almost always held or managed by institutions or individuals whose purpose is to select or interpret images quite narrowly. Like many photographs themselves, custodians and users of photographs come with pre-existing assumptions. Finally, many photographs are often not given adequate attention: objects, documents, other types of illustration and text have always come first. Yet many original prints and negatives do still exist, although they have yet to be adequately defined: no national inventory of photographic collections exists in Great Britain 165 years after the invention of the medium, so major photographic discoveries are inevitable.

The fact that other photographs of the palace could have been taken and might be rediscovered makes for many tantalising possibilities. Portraits of the famous visitors and performers, from Edison to Bruckner, from Zola to Nadar, whether inside or outside the palace, might yet be found. There might be images of the huge variety of objects displayed and for sale, which could bring this extravaganza of consumption, entertainment and commerce to life. The surviving archives of the companies represented in the commercial bazaar may contain new material, while musical archives may detail performances and aeronautical archives might preserve photographs of balloons and aircraft. The full number of exhibitions, shows, sporting events, entertainments and displays at the palace has not been adequately established, so there may still be many opportunities for historians and archaeologists to discover more.

Visual treats and treasures clearly remain to be discovered but, like wrecks, they require con-siderable salvage work before they can be fully appreciated. The use of digital and web technology is helping us solve some of these problems: Delamotte's images are available worldwide through English Heritage's website and we can now examine an online catalogue of every image exhibited in Britain between 1839 and 1865 (see www.peib.org.uk).

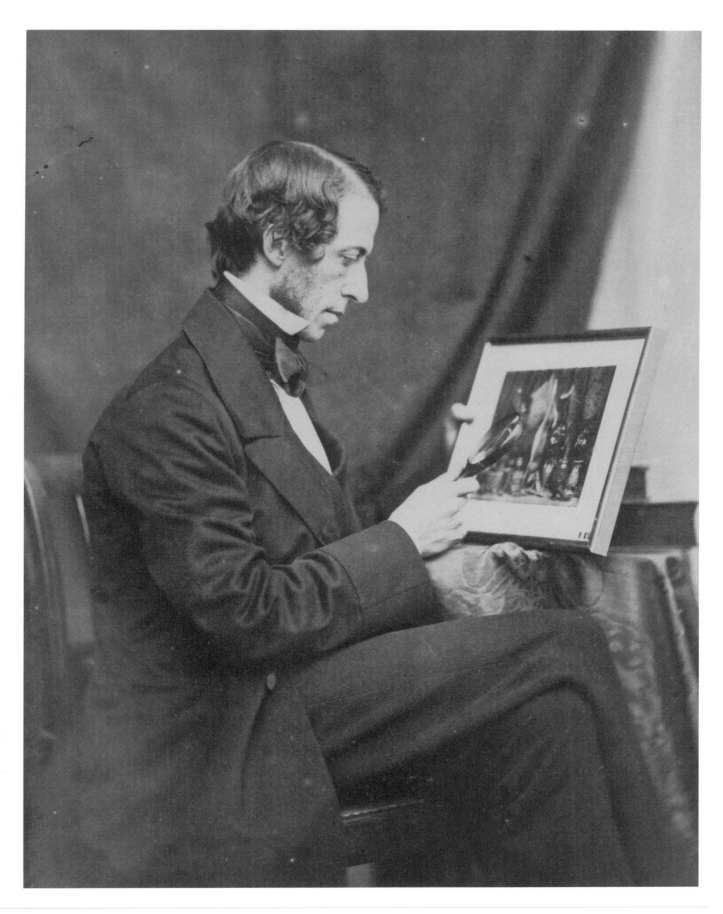

Philip Henry Delamotte
Photographer and Artist

PHILIP HENRY DELAMOTTE (1821–89) is probably better known as an artist and illustrator than as a photographer. Unlike many other early photographers, who often loosely described themselves as 'artists', he has a rather better claim to this title: in 1855 he became Professor of Fine Art at King's College, London, and he also exhibited at the Royal Academy. He does appear in the new *Oxford Dictionary of National Biography* as a 'photographer and illustrator', but it would seem that a closer examination of his work as a pioneer photographer is merited. Delamotte does not appear to have promoted himself like other famous photographers and his work is not as abundant as theirs is today in sale rooms. Apart from his early set of Crystal Palace images he has received very little attention as a photographer, but it is clear that he exercised a considerable influence on the development of early photography in Britain. His association with the Crystal Palace is also far greater than has previously been realised.

Delamotte was one of the key photographic pioneers of the early 1850s. In 1852–3 he helped to organise the first two exhibitions purely devoted to photography in England, with Roger Fenton and Robert Howlett. With the publisher Joseph Cundall, he was a partner in the Photographic Institution on Bond Street where photographs were first sold and exhibited in 1852. In the same year he was also associated with Henry Cole (1808–82), who was one of the key figures behind the first Crystal Palace: Delamotte is known to have given Cole lessons in photography in 1852.

Like Cundall and Fenton, Delamotte was faced with a peculiar problem if photography was to transcend mere portraiture, which had been its

staple since 1839. There was no market for architectural or topographical views, so new opportunities had to be created. The now famous Roger Fenton forged his own way by recording engineering in Russia, war in the Crimea and sculpture in the British Museum, as well as many architectural and landscape views. Both Fenton and Delamotte sought new sponsors in the form of architects, engineers and owners of country estates. To such new and discerning clients they provided fine mounted prints with printed credits. Apart from Holland House in Kensington, little is known of any country house work by Delamotte, but engineers, architects and artists must have been part of his circle. He appears also to have created his own photographic niche by associating himself with the grand projects propounded by Cole and brought to fruition in Sydenham by Joseph Paxton and the Crystal Palace Company.

As a photographer, Delamotte is best known for his set of views of the reconstruction of the Crystal Palace. The photographs were taken weekly between 1851 and 1854, and published in 1855 as *Photographic Views of the Progress of the Crystal Palace, Sydenham*. The images shown in this book, however, are quite separate from this published set and show that his connection with the Crystal Palace Company continued for at least four years after 1855: Delamotte was the official creator of many of the early images of the Crystal Palace between 1852 until about 1860. This connection was far from being just photographic: he illustrated the official guidebooks from 1854 with many sketches, drawings and plans which have little or no connection with his photographs (see p31). Delamotte is also credited with the plan of the palace (front endpapers), and is known to have painted water-

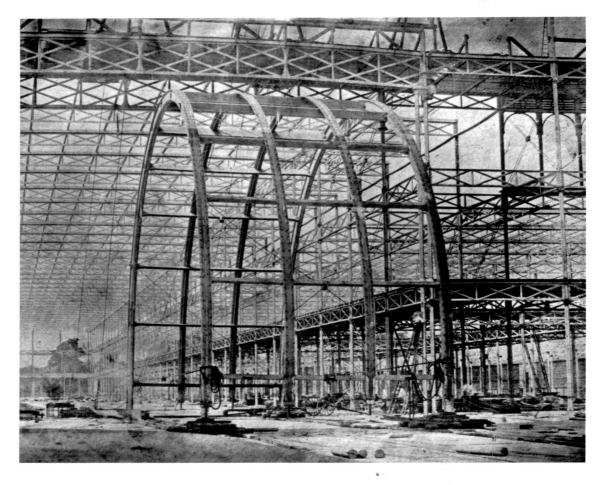

The first Crystal Palace being disassembled
Delamotte, 1852.
The fact that Delamotte took this image suggests that he may have been commissioned by the Crystal Palace Company to document the entire process of change from the end of the Great Exhibition, the re-erection in Sydenham and the whole finished palace complex. He is able to demonstrate just how fast the new photographic reproduction techniques had advanced: like his later images this is probably a print deriving from the new wet collodion process which effectively ushered in the new negative-print medium.
[© Institution of Civil Engineers]

colours or wash drawings of the Fox Henderson yard at Smethwick (facing page). Fox Henderson were the key designers and constructors of the complex prefabricated glass and iron elements. It is therefore clear that Delamotte had a long-standing link with the Crystal Palace (or those who promoted it, such as Cole) for at least two years before and as many as five years after the palace opened.

English Heritage's set of 47 photographs has been provisionally dated to about 1858–9. This dating is based primarily on a report in *The Times* in September 1858 that Delamotte was in the process of creating a set of at least 60 large-format photographs: presumably the 47 reproduced here make up the only known part of this proposed set, created either for the Crystal Palace Company or for the Crystal Palace Art Union – the movement set up to promote the art and educational purposes of the palace at Sydenham. At least nine of these prints, along with prints by Roger Fenton, formed part of artistic prizes that

were given to subscribers of the Crystal Palace Art Union. The University of Maryland holds one of these sets of nine prints, and on the reverse of each photograph is an artistic cartouche, carrying the inscription: 'Photographs executed expressly for the Crystal Palace Art-Union 1859'. If all 47 had been commissioned from this source it would account for the rarity of this set. However, although the dating of this set and the references in *The Times* suggest a date of 1858–9, it is quite possible that some were taken earlier, since they could show the inauguration of the fountains in 1856.

Unlike the first palace, which would only generate potential support for photography for a few months, the second palace was permanent and provided both a stable business platform for Delamotte and a gallery for his work for at least five years. Apart from organising the first temporary photographic exhibition in 1853, Delamotte could also claim to be the first organiser of a more permanent exhibition of photographs in

England, since his own work must have been displayed in the Crystal Palace in September 1858 in the Photographic Gallery. His photographs would have been exhibited alongside those by at least 20 other photographers, including George Washington Wilson, Henry Peach Robinson, Francis Frith, Benjamin Bracknell Turner, Roger Fenton, Alfred Rosling, John Dillwyn Llewelyn of Wales, Henry F Leverett of Ipswich, John H Morgan of Bristol, Francis Bedford, William Morris Grundy, Herbert Watkins, Lock and Whitfield, Dolamore and Bullock, Ross and Thompson, Maull and Polybank, Messrs Mayer, John Jabez Edwin Mayall and T R Williams; the latter, according to some sources, actually worked with or for Delamotte. In effect, all the important photographers of the period could be seen at the Crystal Palace – just as contemporary photographers can be seen today at a similarly revolutionary architectural and educational icon, the Pompidou Centre in Paris.

This permanent exhibition was held in the first gallery, immediately adjoining the Handel orchestra in the central transept, and was described by *The Times* on 20 September 1858 as 'already the only permanent exhibition of the kind in England'. It is not known how long this Photographic Gallery lasted or how it evolved, but it must have lasted considerably longer than the temporary exhibitions elsewhere: the Crystal Palace was run like a museum, with its own heads of department, and was thus quite unlike the first temporary palace.

At an early date the palace therefore provided the public with an opportunity to examine at leisure a range of images by important photographers, at a more accessible venue than the galleries of Bond Street. This reveals a more democratic interest in and accessibility to pioneering photography than has previously been assumed. Such exposure proves that there was a demand well beyond the province of rich connoisseurs and 'gentlemen amateurs'. The fact that images could be displayed for this length of time also

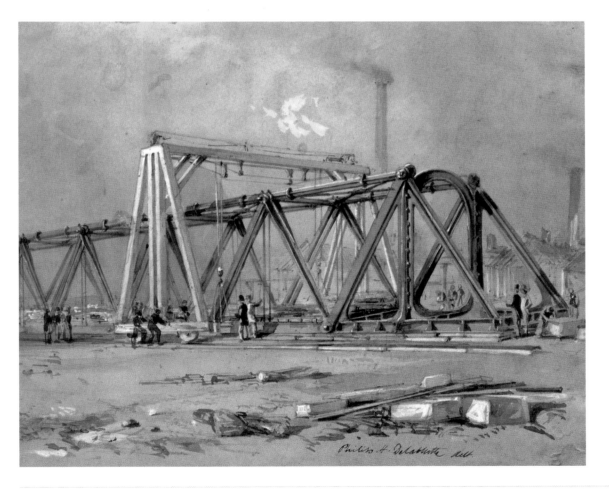

The second Crystal Palace being constructed at Newark Dyke
Delamotte, 1852, colour lithograph.
As well as photographs Delamotte is able to use his artistic skills to convey the scale of activity in the yard of Fox Henderson where the manufacturing of the key structural elements of the vast structure took place. In order to convey the people or the atmosphere photographs would still have been inadequate so Delamotte could here demonstrate his artistic skills. The impetus for such views should not be assumed to be those of a dilettantish artist: he would have been commissioned by the Crystal Palace Company to record their great endeavour.
[© Institution of Civil Engineers]

shows that by this time the issue of the permanence of the photographic image had been resolved; the technical problems with the fading of prints that had existed until the mid-1850s had now been overcome. Like the paintings in the upper galleries nearby, the photographic display at the palace would have been well shaded, which would have inhibited attempts to take photographic views of it.

The photographs would also, like the paintings and much else in the palace, have been available for purchase by visitors. As well as displaying his skill, Delamotte could therefore have directly profited from his work through sales operated via large stereo photograph producers such as Negretti and Zambra and the London Stereoscopic Company, who controlled commercial views of the palace. These businesses clearly had links with the pioneering 'amateur' photographers who supplied images without having 'trade' associations. However, there is little evidence that Delamotte exploited this lucrative trade. Since photographic technology did not then permit the transfer of an image from a large format print into the much more commercial

stereographic format, this suggests that Negretti and Zambra held all the rights to this form of photographic enterprise, although they did attach Delamotte's name to some of these stereocards (which are occasionally credited to 'P H de la Motte'). A huge number of stereo images proliferated in the late 1850s and 1860s at accessible prices, but large-format mounted prints like Delamotte's had a much more limited circulation: apart from being exhibited they would only have been sold individually at considerable cost or presented as prizes.

Despite the fact that only a small proportion of Delamotte's Crystal Palace images were ever 'published' by the Crystal Palace Art Union, a significant number of them have remained in circulation for over 150 years. At least eight have never been out of print or unavailable since they were taken: the Francis Frith Company has issued Delamotte's images without any form of credit since the 1860s and even produced postcards from them as late as the 1960s; the Frith website still displays some of them today. It seems that Frith, one of the largest industrial photographers of the day, who are also known to have acquired

Interior of the first Crystal Palace
Anon: 1851 Stereoscopic daguerreotype.
Photographic images of the first palace are very rare: such views were impossible to reproduce given technical difficulties that were not solved until after 1851. Daguerreotypes were unique photographs which could not be printed and which could only be photographically replicated with difficulty.
[© Christie's]

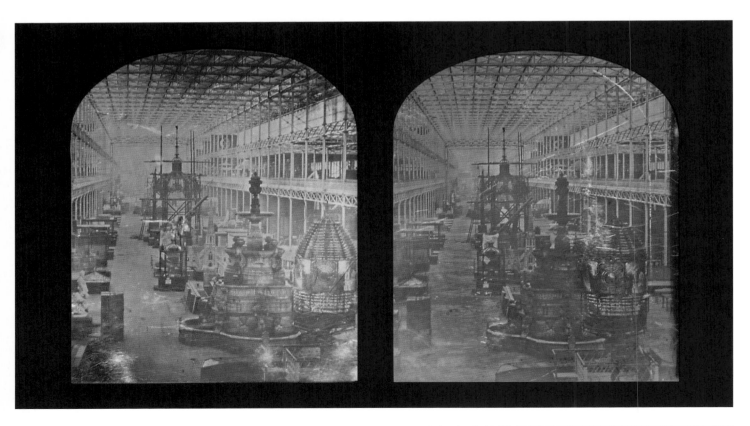

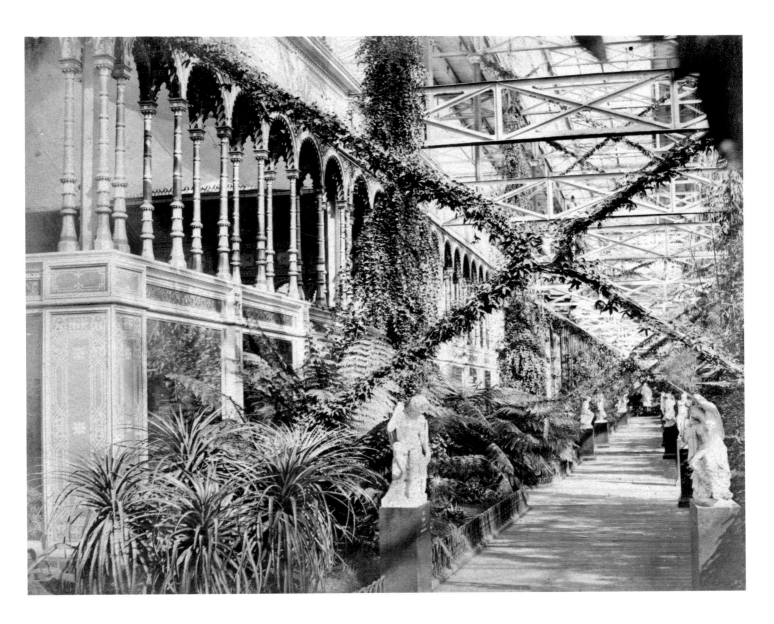

images by Fenton, somehow acquired at least some of the more commercially desirable Delamotte images, and as with many large photographic concerns the origins of those images have long been forgotten. No negatives are known to survive with the original Frith glass negatives at the Birmingham Central Library. In a later revealing letter to *The Times*, published on 1 December 1873, photographer Henry Negretti stated that:

as photographers to the Crystal Palace, and having the exclusive privilege of taking negatives and selling prints of the views and works of art in that building, out of pure kindness, and

without any consideration, [we] granted permission to a Society to take 12 negatives from which prints were only to be taken for giving away as prizes. The negatives were duly taken, the prizes given away, and after the Society was dissolved the negatives were sold to a third party, who is selling prints from them to this very day, very much to our prejudice.

The society to which he refers may have been the Crystal Palace Art Union, the photographer may have been Delamotte and the third party may have been Frith. Negretti goes on bitterly to advise other 'artists' (by which he meant photographers) 'who do not want prints to be circulated

The Sheffield Court
Delamotte c.1859.
Located in the South end of the Nave the Industrial Courts initially displayed manufacturing goods. This Court was designed by Paxton's architectural assistant George Stokes. Many of the southern areas soon became temporary displays or shopping opportunities.
[DP004647]

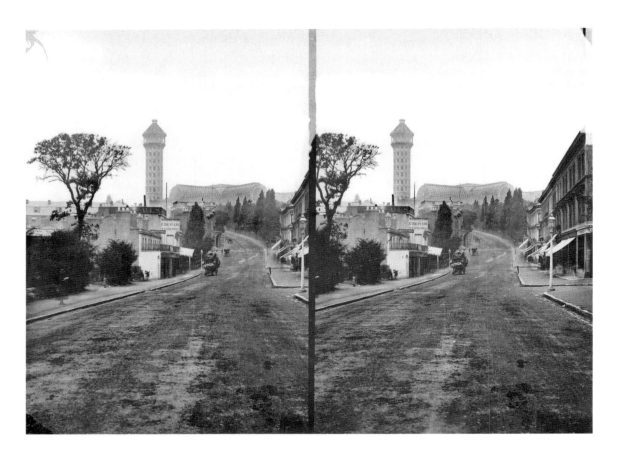

View from the south east up Anerley Road
York & Son large format stereo negative c.1875.
The palace and the southern water tower dominated the suburb around the Crystal Palace. The Paxton Arms public house is visible beneath the tower.
[CC97/1546]

not to pay for the prints without having the negatives delivered up to them'. The case cannot be proven, but this story of photographic piracy may possibly explain why such extraordinary images could partially survive elsewhere, yet as a set remain undiscovered for 150 years: they were commissioned by a body which was soon dissolved, and subsequently acquired by another photographer after Delamotte had relinquished most of his photographic interests.

Delamotte's later photographic work at the Crystal Palace was carried out in the short period between 1854 and the early 1860s, when commercialism was taking over from pioneers, and when the social and aesthetic status of photography was being reconsidered. His own attitude to his work as both artist and photographer illustrates the ambivalent status of photography at the time. He seems to have compartmentalised his creation of images, producing 'popular' Crystal Palace images not in photographs, but in other, purely artistic forms. Later photographers often used their images as the basis for engravings or lithographs which could be disseminated much

more cheaply – halftone photographic images were not developed until much later in the century. Many *Illustrated London News* images actually derive from photographs. Delamotte, however, seems to have preferred to create his own line drawings and avoided any link with his own very similar photographic views. This fastidiousness may be associated with the difficulties of composing natural figures in photographs, and the comparative ease with which he could insert human incident and colour effects in his drawings. By continuing to work as an artist he was also hedging his bets for the future, providing illustrations and cheap reproductions which probably had more commercial value and acceptance in 'polite' circles than did photographs.

This distinction by Delamotte himself is notable, and may form part of his gentlemanly outlook towards photography: commercial illustration was polite, but commercial photography was not, and neither Delamotte nor Fenton ever advertised. Much of the rest of English photographic history derives from such artificial Victorian distinctions. Fenton abandoned pho-

tography in the early 1860s and returned to his previous career as a lawyer; Delamotte appears to have done much the same and returned to being an artist and a teacher. In 1856 both Fenton and Delamotte resigned from the council of the Photographic Society because of the increasing friction between those involved with trade and 'professional gentlemen'; yet a double standard operated which allowed Delamotte to sell images while remaining eligible for membership of a professional photographic organisation that disparaged the very notion of trade.

Nonetheless, Delamotte's fame at this time was as a photographer, and so we find this mentioned even in the credits to his lithographs (see below). He is intimately linked with the key set of lithographic views of the Crystal Palace published by the architect Mathew Digby Wyatt (1820–77) in 1854. All 24 plates of the first series of this colourful set are annotated 'P H Delamotte,

Photographer', even though these have only a distant relation to the actual photographs we now know that he took (see p98). This curious anomaly suggests that some contemporary confusion must have existed in people's minds between the various 'recording' media: why else would Delamotte be described as the photographer for an illustration which was not in any way linked with a photograph? One explanation is that the fame Delamotte had as a photographer lent publicity to sets of images which were much more easily accessible than photographs, at a time when photographs were still considered as ephemeral because of the problem of fading. The other possibility is that the title 'Photographer' lent veracity to the lithograph: engravings were notoriously unreliable as records and the link with the new medium would have implied a greater faithfulness to the original that we now take for granted in photographs. It is interesting

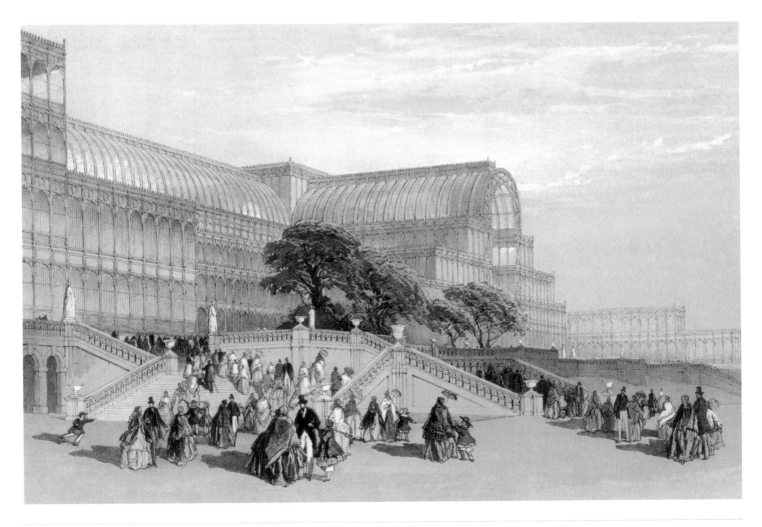

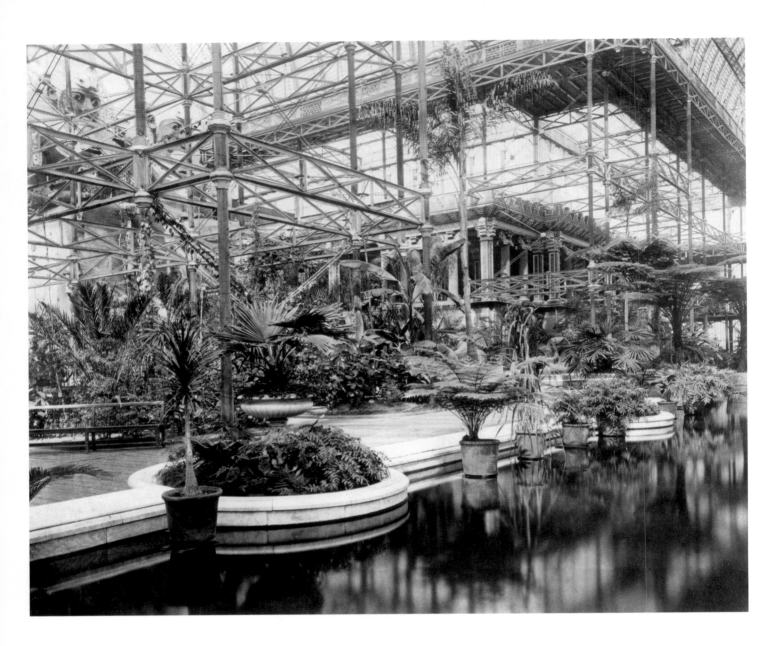

to note that an 'F Bedford', presumably the Francis Bedford who was another photographer/artist of the period, is credited as being the lithographer of seven of the Wyatt set: the links between photographic and artistic prints during this transition period, when both forms overlapped but could be created by the same artists in differing media, are thus somewhat blurred and still not fully understood.

There is also evidence of another puzzling hybrid between photograph and lithograph. Delamotte is credited by the late Clive Wainwright of the Victoria and Albert Museum as the creator of four so-called 'hand-coloured lithographs', yet these do not appear to be lithographs at all but some form of hand-coloured photographic transparencies. Whatever their provenance, they are among a very few sensitive views derived from photographs which convey any accurate idea of the colour scheme inside the palace; as such, they are extremely important hybrids in the absence of proper colour photography. Early forms of colour records were technically possible in the decade before World War I in the form of Lumiere autochromes , but even though such plates were commercially available for over 30 years (from about 1907 until 1936), the only known colour views of the Crystal Palace were

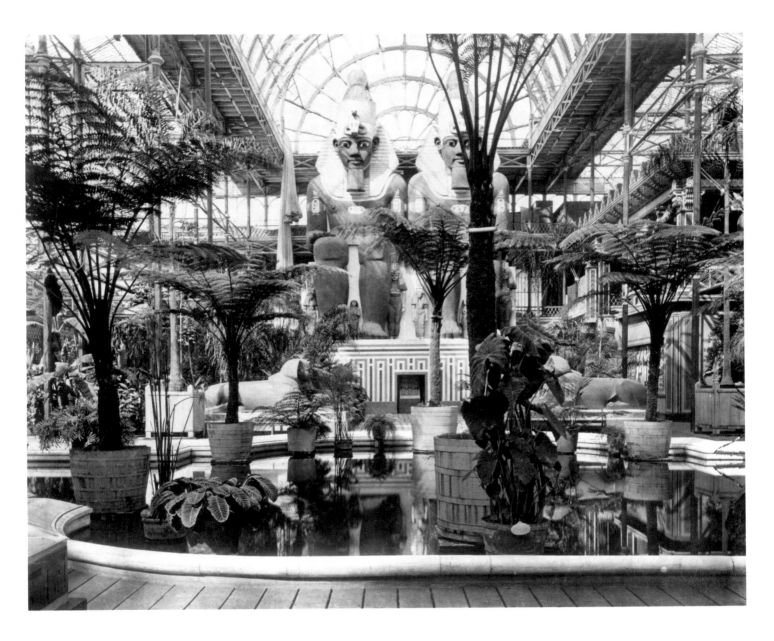

taken using one of the few other viable colour processes, Dufaycolour. The local photographer Arthur Talbot, whose collection is now at the Crystal Palace Museum, just managed to capture the palace before the fire of 1936 (p6 and back cover). It was just at this time that Kodak and others had developed early versions of the modern standards in colour photography, so it is tantalisingly possible that others with access to this early stock could have unwittingly added to these very few colour records.

Opposite: **Nineveh Court and Pools** *[FF91/332]*

Above: **Abu Simbel Figures in North Transept** *[FF91/333]*
See also p15.

Delamotte? c.1860.
These 'hand-tinted colour lithographs' may actually be hand-tinted forms of photographs taken by Delamotte – though none of these overlap with his set of 47 illustrated in this book. Though tonally inaccurate this carefully prepared set of views provides the only known contemporary photographic interpretation of the colour scheme and planting devised by
Owen Jones and Joseph Paxton. This is the closest impression we can gain of the effects that both men successfully created – unless new colour images of the 1930s come to light.
The fourth image, not reproduced here, is FF91/331.

Sir Joseph Paxton
Palace Designer

I N 1850 JOSEPH PAXTON (1803–65) designed the new glasshouse at Chatsworth House, Derbyshire, to house the *Victoria Regia* or *Victoria Amazonica* lily, which had been cultivated there the year before. In his 1850 lecture Paxton told the Society of Arts how his inspiration for the structure had come from the lily leaf itself and its extraordinary load-bearing capacity, which he called a 'natural feat of engineering'. The lily's unique natural structure had already been noted by a plant collector in the Amazon, who described a leaf that seemed to resemble cast iron just taken from the furnace, its ruddy colour, and the enormous ribs with which it was strengthened, increasing the similarity. Paxton described how cantilevers radiated from the centre of the leaf, with large bottom flanges and very thick middle ribs with 'cross girders' between each pair to stop the leaf from buckling. In his new lily house, the ridges and furrows on the great horizontal surface of the roof acted like the cross girders on the leaf. Both the lily and the roofing system featured at Sydenham. Paxton had intended to write a guidebook to the planting which was never published, but this direct link between discoveries in natural history and advances in structural engineering is striking.

Much has already been written on Paxton's prefabricated system and its antecedents at Chatsworth. It is a mistake to assume that either building was simply made from a fixed number of standardized components. While the palaces mark a turning point in the history of prefabrication, the apparent simplicity of the building process concealed an extraordinarily complex construction, much of which had to be assembled by hand. Paxton himself was the key to the building's success: he was able to develop and execute a highly complex plan and manage both the engineering and the human resources.

Much of the actual design of the palace, however, was by the engineers Fox Henderson, and among all those associated with the Crystal Palace the contribution of Sir Charles Fox (1810–74) has been sorely overlooked. Fox Henderson provided the components and many of the practical plans for Paxton in 1850, and Fox's company single-handedly designed, manufactured and tested all the components of this immensely complex structure.

George Stokes (1827–74), Paxton's architectural assistant throughout his career as a

Victoria Regia Lily
Paxton's structural ideas were inspired by this botanical wonder and as such these lilies were cultivated inside the palace.
[© Hulton-Deutsch/Corbis]

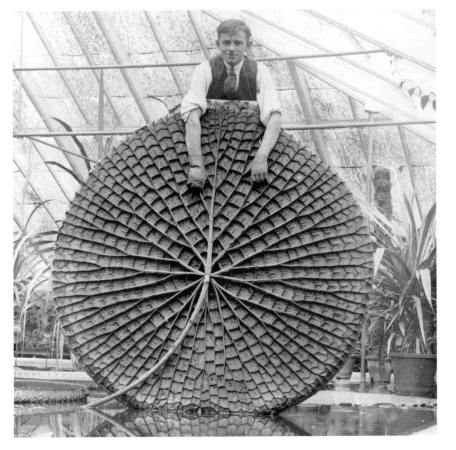

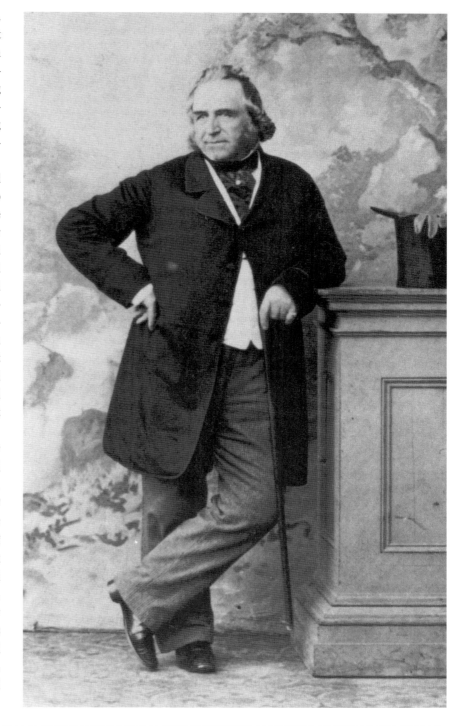

Sir Joseph Paxton 1801–65
The self-confident pose taken c.1860 is similar to the iconic image taken of Isambard Kingdom Brunel who designed and built the Crystal Palace water towers. Unlike Brunel however, there seem to be no photographs of Paxton beside his own creation. Such images must have been taken yet they remain to be discovered.
[© Time Life Pictures/Getty Images]

'gardener', has also received scant attention. Stokes trained under the eminent architect George Gilbert Scott and was directly involved in many of Paxton's architectural projects, including some of the Crystal Palace courts. Working with Stokes, Paxton went on to add more conventional architecture to his portfolio, including country houses such as Mentmore, Buckinghamshire.

When the Crystal Palace was completed Paxton organised thousands of the navvies who had built it to go to the Crimea. There, as the more formal (but not strictly military) Army Work Corps, the 3,700 men used what we would now consider sophisticated design and build techniques on projects such as barracks and road-building. Paxton's abilities to fuse landscaping, architecture and the practicalities of building itself were alien to most architects, which perhaps helps explain the hostility they felt towards him: a man they called a gardener had made them feel like under-achievers and had used iron, glass, plants and men in a manner that threatened their self-esteem.

Apart from the prehistoric monsters, the only extant monument in the whole vast Crystal Palace site is the one to Paxton himself (see p41). The original plinth of this colossal bust by W F Woodington, put up in 1873, was designed by Owen Jones and was appropriately inscribed '*Si Monumentum Requiris, Circumspice*' – 'If you seek his monument, look around'. Both the plinth and its inscription have, like the palace, disappeared. The re-instatement of this inscription (originally written by Christopher Wren's son for his father's tomb in St Paul's Cathedral) would at least remind visitors that Paxton designed the surviving park. Joseph Paxton synthesised all his talents and those of the age in the Crystal Palaces.

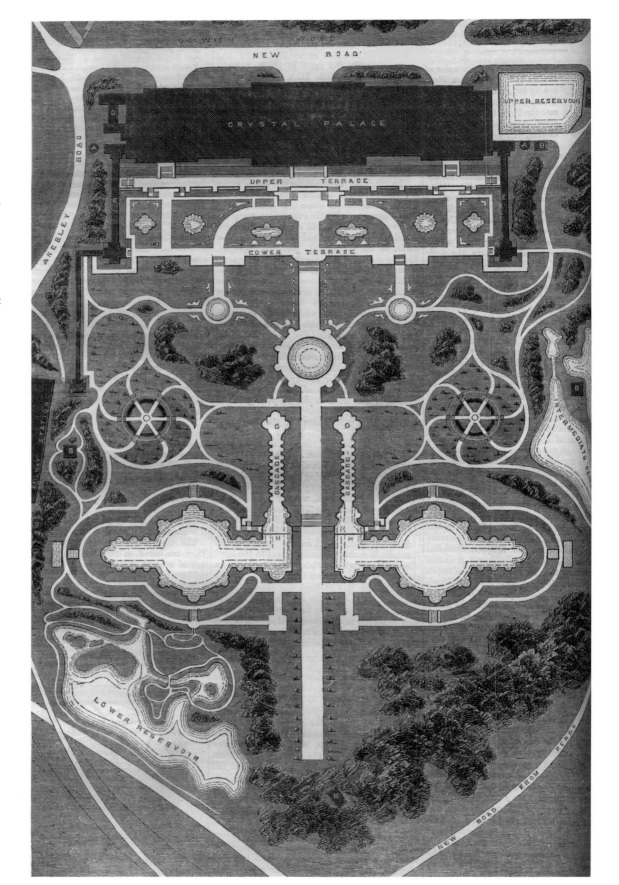

Plan of the Gardens
*The Builder, June 21, 1856.
The hugely elaborate layout
of paths, promenades,
fountains and gardens can
only be grasped through
plans which are themselves
only snapshots: the initial
scheme depicted here does not
reflect the series of changes
brought about by the
subsequent removal or
addition of features.*

Crystal Palace, Park and Gardens

P AXTON'S OTHER CONTRIBUTION to the Crystal Palace at Sydenham was the factor which almost certainly proved the most costly: the gardens and fountains. The gardens had extremely elaborate and colourful planting and the park was laid out on an immense scale commensurate with the building. The fountains were often compared with those of Versailles: an early design for water towers designed to supply the fountains had to be abandoned, and Isambard Kingdom Brunel (1806–59), the nation's foremost engineer, had to be employed to create the two huge towers at either end of the palace which held the immense amount of water required to provide the pressure for the fountains.

The fountains were not ready in 1854 and it was not until 1856 that the full set was in operation. They were so complex and so difficult to maintain that within a few decades the main jets were abandoned, though smaller fountains continued to operate until World War I. The basins for the two largest fountains were so large that they were later converted into a football stadium: the annual final of the FA Cup was played here for 20 years, and today the name Crystal Palace is almost exclusively associated with the football club of the same name. But other games were also associated with the palace: the famous W G Grace played for the Crystal Palace cricket team, and after World War II the park became an important venue for motor racing. Pioneering balloon and powered flights were made early in the 20th century and the palace was the site of the first ever aeronautical exhibition in 1868. In the 1950s the park became the site of the National Sports Centre, with one of the largest international athletics tracks and an Olympic-sized swimming pool.

Circuses, funfairs and all forms of popular entertainment were held here from the start. The celebrated tightrope walker Blondin performed many times inside the palace. A purpose-built and separately owned panorama building flourished between 1881 and 1910 on the site of the Rosery; it was owned by a Belgian company whose first show was the 'Siege of Paris'. This circular building later became a boxing arena before becoming part of the early Baird television studios. The BBC TV transmitter tower erected in 1955 was at the time compared with the Eiffel Tower – an ironic comparison, since although the pylon was several hundred feet higher than the Eiffel Tower, it was its late glass neighbour that should truly have been

Main Lower Terrace fountains in operation
Anon: stereo c.1860.
Views of the fountains in operation are not very common because the hydraulic system was so elaborate and expensive to operate and maintain that full displays only occurred a few times a year.
[BB68/05592]

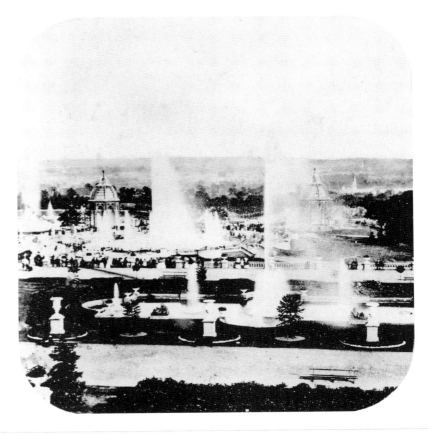

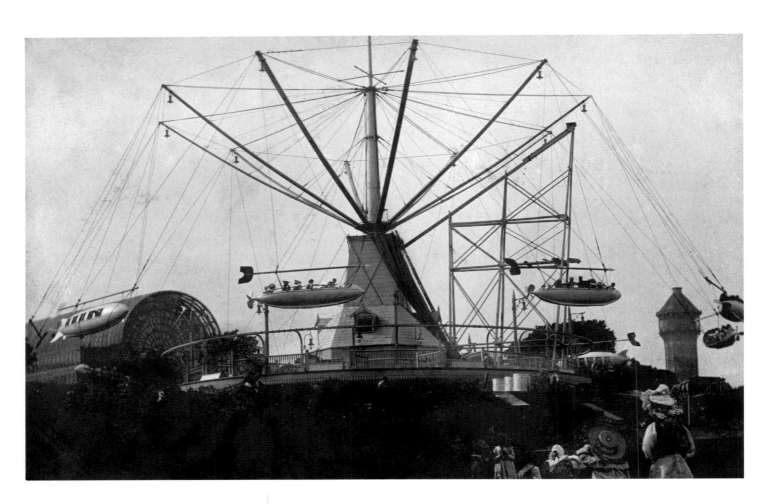

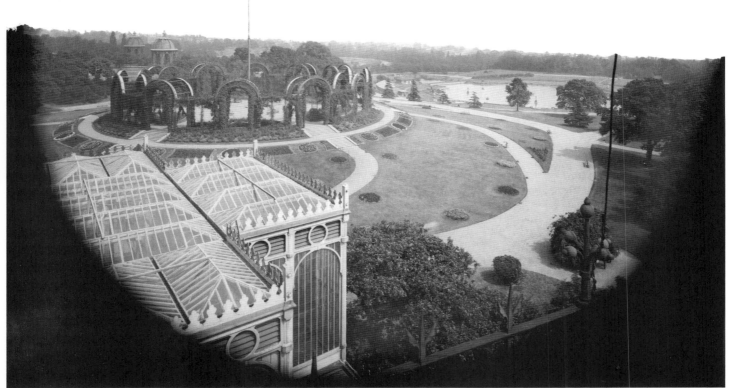

compared with the Parisian icon. In 1871 W A Lloyd, the pioneer creator of the modern aquarium, built only the second example in Europe on the site of the burned and demolished North End. It had a revolutionary closed continuous circulation that made it possible to keep animals alive in tanks without changing water. One of the redundant water towers was eventually opened to sightseers, but most of the space was used by the Crystal Palace School of Engineering.

Probably the largest, and most evanescent, example of the botanical attractions was the giant sequoia from the then recently discovered redwood groves in Calaveras, California (see p40). This *Sequoiadendron giganteum*, though over 30m high, was only the lower portion of a tree three times this height and in fact the part displayed at the palace was only the tree's bark, supported by internal scaffolding – it may thus have acted as a giant chimney for the disastrous fire of 1866. It was because many people doubted the existence of such trees that this example,

called the Mother of the Forest, was felled in 1854 specifically for exhibition purposes, first in the New York Crystal Palace and later in Sydenham, where it was patriotically called the *Wellingtonia gigantea*. The cynical stripping of this Sequoia helped to win ecological protection for the whole grove in California from which it came: the remaining 'Big Stump' there is still an attraction – with a circumference of 25m (without the bark) it has been used as a dance floor. Contemporary images of the tree before it was removed may still exist and a separate Crystal Palace guidebook to the tree was produced in 1857.

Inside the palace Paxton had acquired the largest extant collection of rare trees, shrubs and other plants from the famous Hackney nursery Loddiges, which had the largest collection of palms in England. Along with the giant lilies, the tropical plants created an exotic botanical atmosphere totally unlike the Great Exhibition: this was the Winter Garden which Paxton had promised

Facing page, top:
The Maxim Captive Flying Machine
NMR postcard c.1910
By 1910 the site of the Rosery had been replaced by a fairground including the rather unsafe-looking aerial ride designed by Sir Hiram Maxim who lived nearby and also invented the machine-gun.

Facing page, bottom:
South west corner of Gardens with Rosery
York & Son c.1875
The Rosery is visible from the glass corridor linking the palace with the Low Level Station. It was later replaced by a circular building showing panoramas – rather like a Victorian version of the IMAX cinema.
[CC97/1548]

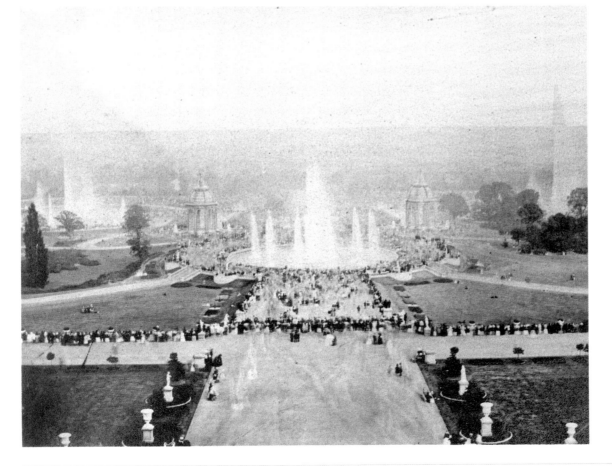

Main Fountains from Garden Front
Delamotte c.1859.
The main lower fountains in operation during the visit of 45,000 members of the Ancient Order of Foresters who held several huge outings in the late 1850s and early 1860s.
[DP004603]

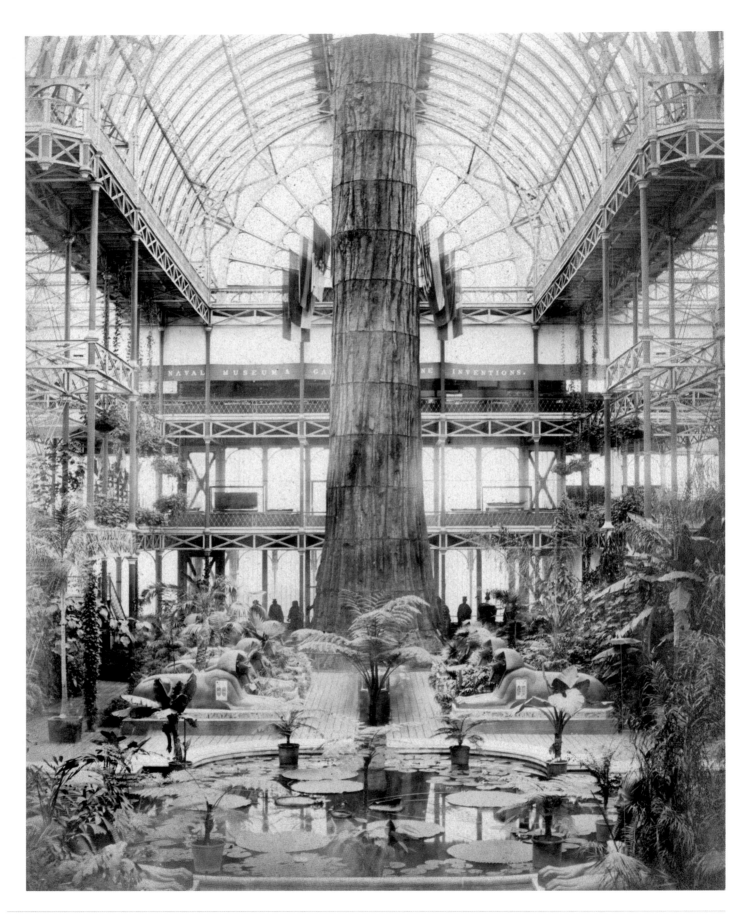

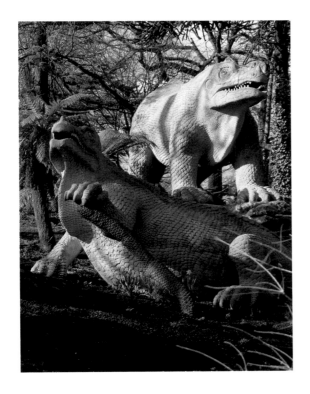

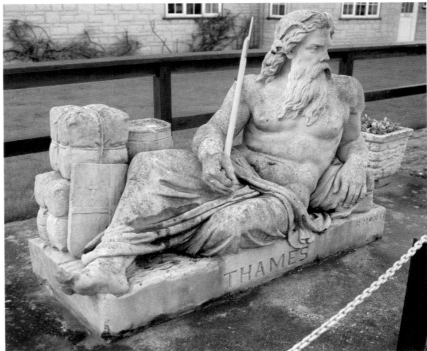

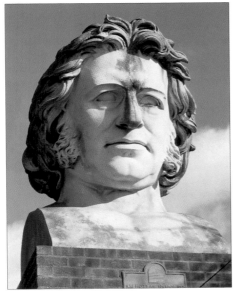

North-east Transept
Delamotte c.1859.
The giant sequoia tree from California was displayed at the New York Crystal Palace in 1853 and was destroyed in the first Sydenham fire in 1866. The controversy over the removal of the tree just to exhibit the bark helped to bring about the conservation movement which created the National Parks in the USA. Note the Naval Museum in the gallery behind.
[DP004612]

after 1851. Animals as well as plants populated the tropical North End, including monkeys, turtles, fishes, birds (an aviary is visible in the plate on p81) and even a baby hippopotamus. Many of these perished in the fire of 1866, and only the aquarium continued the natural history theme of the palace attractions in later years.

Though so much has disappeared, one of the most bizarre attractions of Crystal Palace Park still survives: the prehistoric monsters ("extinct animals" see back endpaper). Intended as educational exhibits, they were created within a decade of the first use of the word dinosaur, and over 20 of them survive to show us how contemporary experts imagined what these creatures might have looked like. It is ironic that the only surviving original assemblage associated with the Crystal Palace, now given official listed status as a group of historic structures, should depict and remember the most distant past, when the adjacent, modern wonder has now completely disappeared.

Top left:
Crystal Palace monsters
Two of the listed monsters that survive in the palace grounds.
[EH/Derek Kendall]

Top right:
'Father Thames'
by Raphael Monti.
This figure, now at Lechlade, Gloucestershire, is one of the few surviving pieces from what was the largest display of public art ever mounted in Britain.
[EH/Peter Williams]

Left:
Bust of Joseph Paxton
The colossal bust by E H Woodington was erected on the Upper Terrace after Paxton's death in 1865 and acts as the only reminder of his works inside the Crystal Palace Park.
[EH/Derek Kendall]

Owen Jones
Architect and Designer

JOSEPH PAXTON is so well known for his connections with both of the Crystal Palaces that another of the key designers also associated with both structures tends to remain in the wings, even though he has equal claim to fame. Owen Jones (1809–74) is now almost exclusively known as the author of *The Grammar of Ornament* (1856), which remains one of the first and most influential studies of design and colour. He had spent years in Spain studying the intricate designs of the Alhambra Palace; a recent study of the Alhambra stated that the level of recorded detail generated by Jones was so thorough that his plans of the 1840s were still the most accurate in existence and would be the only source available for any reconstruction after a disaster. But Jones was also an architect, and was closely associated with the development of printing techniques. Such was his thoroughness in attempting to produce authentic colours that he himself developed a pioneering chromolithograph process at his home near the Adelphi on the Strand.

The results of Jones's experiments with colour were spectacular, as was the controversy which ensued when he applied his colour theory to the interior of both the first and the second Crystal Palaces. Colour had an enormous impact on those who stepped inside either palace, but our ability to comprehend or reproduce these effects is imperfect. It was only through lithography that some of the effects of his sophisticated system of colours could be reproduced; the existing photographic evidence is very slim, since modern colour processes were still in their infancy in 1936 when the second palace burned down. It is technically possible that pre-World War I autochromes could exist, but the only known colour views appear to be those taken by Arthur

Talbot just before 1936 (see p6 and back cover). The striking colours used in the Fine Arts Courts can be gauged and reproduced from Jones's own seminal publication *The Grammar of Ornament*, but the overall effect of the subtle use of colour on the interior iron structure is very difficult to convey without overemphasising tones. Most non-photographic media cannot tell us exactly how Owen Jones managed to steer a course between no colour, or a single colour, on the one hand and too much colour on the other. As it was, he achieved a significant balance of light, colour and foliage which contributed to the magical effects visitors experienced as they looked down the immense vistas of the palace.

Equally important, Jones was the chief designer of the Fine Arts Courts. In conjunction with the architect Matthew Digby Wyatt, he designed and supervised the entire set of courts which filled the north end of the nave. Jones himself wrote the sections of the official guidebook for the Alhambra and Egyptian Courts. The colossal pair of Abu Simbel figures came from the informed designs of Jones, but they did not survive the fire of December 1866. The views taken by Delamotte therefore give us an idea of just what an impact these statues must have had on visitors: with the exception of a few privileged tourists, most of those who came to the palace would have had little conception of the scale or decorative nature of such monuments.

The design and contents of the courts were a convincing mix of accurate copies and hypothetical reconstructions. These courts were faithful enough to convey the array of historical styles that supported the educational intention of the Crystal Palace Company, while providing a spectacle which has never been equalled. Owen

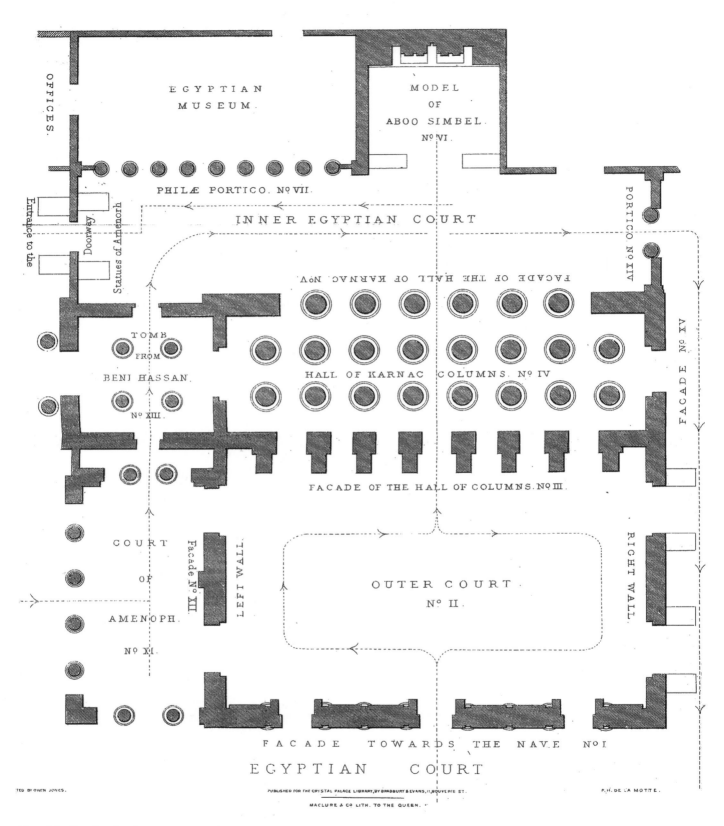

OFFICES.

EGYPTIAN MUSEUM.

MODEL OF ABOO SIMBEL. Nº VI.

Entrance to the

Doorway

Statues of Amenorh

PHILÆ PORTICO. Nº VII.

PORTICO Nº XIV

INNER EGYPTIAN COURT

FACADE OF THE HALL OF KARNAC Nº V

HALL OF KARNAC COLUMNS. Nº IV

FACADE Nº XV

TOMB FROM

BENI HASSAN.

Nº XIII

FACADE OF THE HALL OF COLUMNS. Nº III.

COURT

OF

AMENOPH.

Nº XI.

Facade Nº XII

LEFT WALL.

OUTER COURT Nº II.

RIGHT WALL.

FACADE TOWARDS THE NAVE Nº I

EGYPTIAN COURT

ITED BY OWEN JONES. PUBLISHED FOR THE CRYSTAL PALACE LIBRARY, BY BRADBURY & EVANS, 11, BOUVERIE ST. P. H. DE LA MOTTE.

MACLURE & Cº LITH. TO THE QUEEN.

Plan of the Egyptian Court
Delamotte, plan from *Description of the Egyptian Court*,
by O Jones & J Bonomi, 1854.
Delamotte dominated every media associated with the depiction of
the palace: lithographs, line-engravings, plans and photographs.

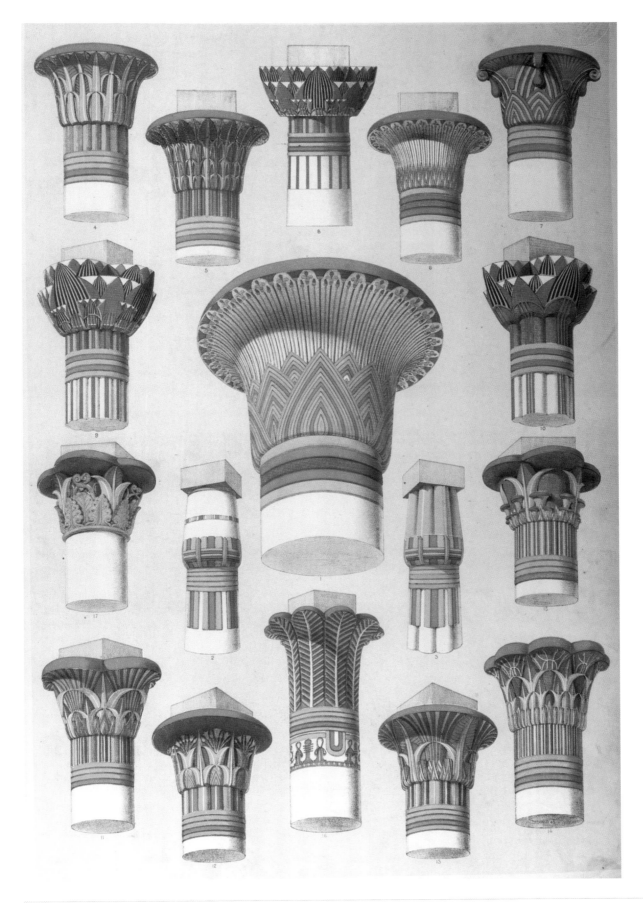

Egyptian ornament from Owen Jones's *The Grammar of Ornament*, 1856.

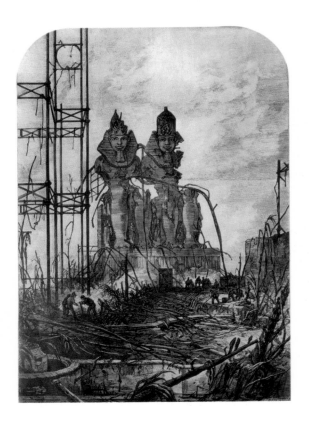

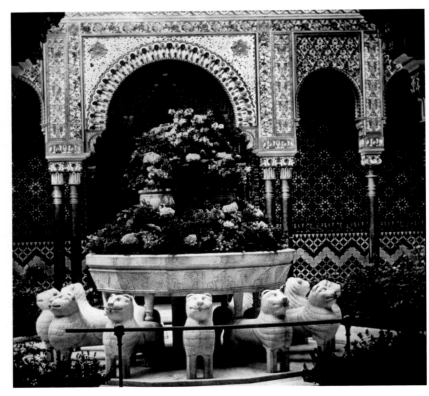

Jones was as archaeologically accurate in his use of colour as the evidence available to him allowed, and his work highlighted the vexed question of the application of colour to ancient sculpture and architecture – a question which is often still avoided, even though we now know that many now bare pieces of well-known sculpture were once highly coloured.

In his guide to the palace's Alhambra Court, published in 1854, Jones himself quoted the verses in honour of the builder of the Alhambra, Iman Ibn Nasr (p 1), which he uses to support his main arguments for the existence of the palace:

> *It would be difficult to find a more appropriate introduction to a visit to the Crystal Palace at Sydenham, than these eloquent words of an Arabian poet of the thirteenth century in honour of a building which appears to have been the glory of his age, as the Crystal Palace may become of our own. Like the Moorish palace, it contains many wonders which require but the attentive examination of minds willing to "estimate them", in order that the benefits of many "commentaries may be reaped".*

Jones saw the Crystal Palace at Sydenham as a project to educate by showing examples of the best of previous civilisations. He thought that one of the most important lessons of the Great Exhibition of 1851 was that it revealed Britain to be 'far behind other nations in the Practice of the Arts'. When the government abandoned the palace to the Crystal Palace Company, 'it fortunately fell into the hands of men animated by the most noble desire of rendering it subservient to the education of all classes, whilst providing also for their innocent recreation'. In his own introduction to the Alhambra Court in the official guidebook he clearly hoped that the new palace might remedy the defects revealed by the Exhibition of 1851. The object was to educate to develop a future public taste which might be better able to distinguish good art from bad:

> *When the British public shall have had time to study and profit by the marvellous art-collections here gathered under one roof, with the history of the civilisation of the world before them, with an opportunity of examining side by side portions of buildings of every age, they will*

more readily be convinced of the folly of attempting to adapt to new wants styles of architecture which have ever been the expression, of the wants, faculties, and sentiments of the age in which they were produced, instead of seeking in every style for those general principle which survive from generation to generation to become stepping-stones for future progress.

This is also a veiled reference to what was becoming very evident: the burgeoning Gothic Revival which was to transform British taste for the coming decades. Significantly, Jones was ahead of most subsequent Victorian architects and designers in his ability to look dispassionately at past styles and learn from them. He regarded it as absurd that architects should view 'all these various styles, thus constantly shifting, as so many quarries from which we may gather stones to erect the buildings of the present day!' His opinion of the Gothic Revival, which had only just begun, was severe. The Islamic religion, he believed, had spread extremely rapidly and had at the same time produced an art in union with its poetic and imaginative doctrines. This civilisation, unlike that of the Gothic period, still practised its art, while the reuse of the Gothic showed 'the utter impossibility of consistent reproduction. Cloisters without monks, embattled towers without an enemy, are exhibitions of equal folly.' A W N Pugin (1812–52), the most fervent advocate of the Gothic, had helped with the design of the Gothic Court in 1851, but Jones was attempting to put what was soon to become the most pervasive style into context, so that designers could learn from the variety of the past and create their own applied art.

Greek and Roman Courts
Copies of the Venus de Milo and other versions of Venus from Naples and the British Museum were displayed in front of a scale model of the Parthenon.
[BB86/03430]

Jones saw his age as having

Entrance to the Medieval Court
Delamotte c.1859.
Based on specific locations in England and Europe the Court was designed by T H Wyatt who collaborated with Owen Jones on the overall design of the ten Fine Arts Courts. Like Jones he was also criticised for applying the evidence of colour to the monochrome survivals of the past.
[DP004631]

'no principles, no unity; the architect, the upholsterer, the paper stainer, the weaver, the calico printer, and the potter, run each his independent course; each struggles fruitlessly – each produces in art novelty without beauty, or beauty without intelligence'.

The art collections of the Crystal Palace therefore addressed themselves directly to the eye, but would at the same time induce study and reflection, and so help to dispel the main cause of the decline of the arts, public ignorance. He believed

that no improvement could take place until the public was better educated in art. The idea was to educate consumers by improving their standards of taste: their choice would then encourage good design in a whole range of products. This was one reason why the selling of merchandise was encouraged within the palace, which might be considered a giant design centre with the aim of raising the level of education in the wake of industry's giant leap forward.

Many of the millions of visitors might not have been fully aware of the aims expressed by Owen Jones and others, and the displays themselves may have been somewhat disconnected or badly

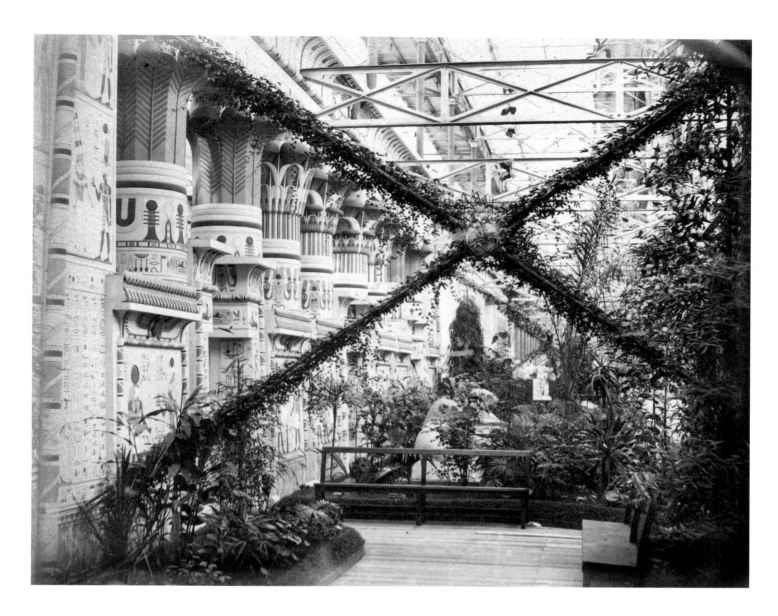

signposted. Nevertheless, with the number of visitors approaching 100 million over 82 years, it is quite possible to argue that Jones and his colleagues did indeed influence taste more than many of their contemporaries and that this influence continued for many decades after his death in 1874. We need to be aware that Jones was arguing against the prevailing opinions of Pugin and Ruskin. Indeed Ruskin, who lived

nearby at Denmark Hill and who attended many musical events in the palace, was consistently critical of everything else to do with it: he even describes it as 'devoid absolutely of every kind of art, and so vilely constructed that those who traverse it are continually in danger of falling over the cross-bars that bind it together'. His negative views have contributed to the obscurity that has surrounded the palace ever since.

Egyptian Court
Delamotte c.1859.
The mixture of huge coloured Egyptian ornament with modern prefabricated iron covered with ivy gave Delamotte the opportunity to experiment with composition. The ivy must have been necessary so that visitors did not bump into the cross-bracing.
[DP004618]

Henry Negretti
Photographic Entrepreneur

THE FIRM OF NEGRETTI AND ZAMBRA is known for two things: scientific instruments and stereo photographs. In late 1854 they acquired the franchise to supply photographs within the Crystal Palace. All discussion of the nature of this arrangement and the history of this important company appears to have suffered not only from the 1936 fire that destroyed the palace but also from the bombing of the company's main offices in 1941. The almost total absence of original records relating to the company's photographic activities may also partly be due to its commercial nature. Yet like Delamotte, Henry Negretti (1818–79) has serious claims to significance in any history of photography. (Joseph Warren Zambra (1822–97) appears to have been Negretti's business partner and was not a photographer.)

Born in Como, Italy, Enrico (Henry) Angelo Lodovico Negretti came to England when he was 12 and steadily built up a business in Hatton Garden. He initially specialised in barometers and later diversified into other scientific and optical instruments, gaining an international reputation. He was an entrepreneur who embodied the dynamic Victorian virtues, and as such is an appropriate representative of other commercial concerns inside the palace: he used his position to combine business, scientific research and photography. Negretti promoted his company by engaging in a series of scientific advances or product developments, and was one of the foremost providers of a huge range of photographic equipment. He clearly therefore brought considerable expertise, both technical and commercial, towards the creation of the Delamotte photographs which are the subject of this book: he was not just the printer, as he is credited on the mounts.

Negretti's accurate instruments were vital to weather research and he had close connections with pioneer balloonists who were encouraged by the Crystal Palace Company as a spectacle to generate revenue. Balloons attracted eminent scientists such as James Glaisher (1809–1902) who required more sophisticated measuring devices for the upper atmosphere; Glaisher used these instruments himself on flights from the palace in the early 1860s and his portrait was taken by Negretti. Such is the extent of these balloon and later

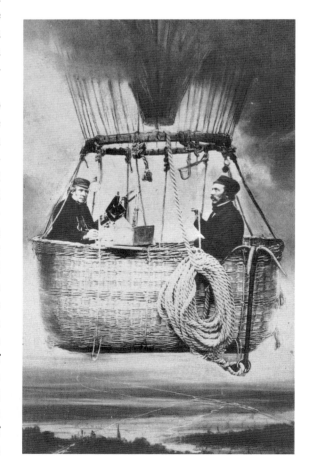

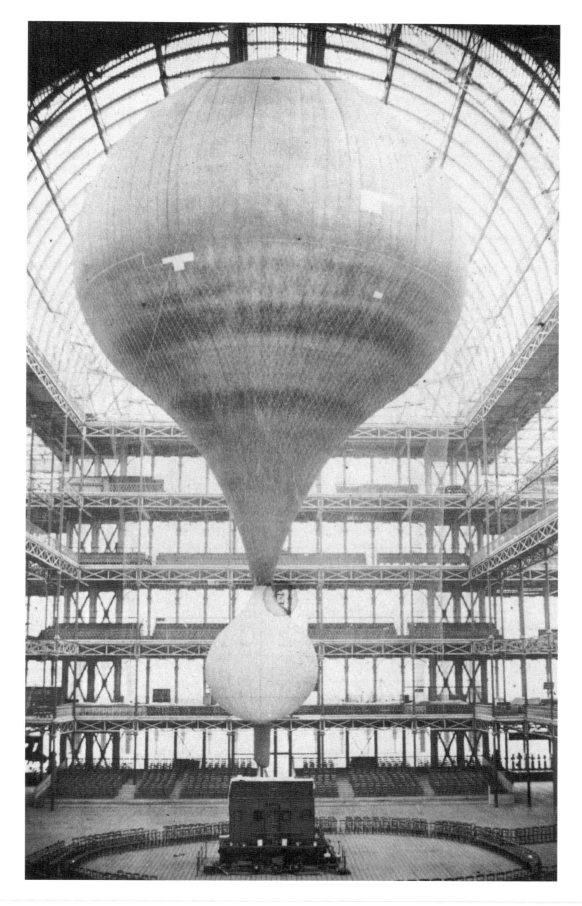

Nadar's Balloon
Negretti & Zambra, 1863.
The height of the transept was 108ft. Since the enormous balloon must have been at least partly inflated, one could argue that Nadar 'flew' in England.
[© Royal Astronomical Society]

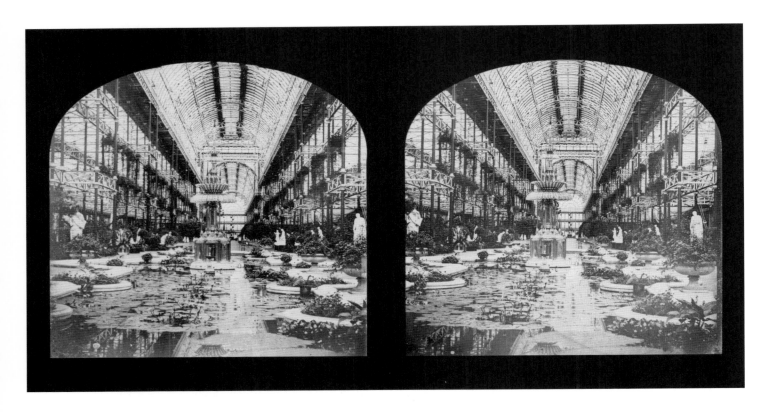

aircraft activities that the palace has a justifiable claim to be one of the key sites in the history of aviation: the first exhibition relating to aviation in the world took place in the Crystal Palace in 1868.

Negretti took his aerial instruments one stage further, however, and began a series of different balloon experiments using photography. He took some of the very first air photographs from a balloon launched from the Sydenham gasworks and piloted by Henry Tracey Coxwell (1819–1900) in May 1863, and made at least one flight accompanied by Negretti's assistant George Collings (1823–88) in 1864. If they still exist these images could be as important as those taken by another aerial self-publicist, the French photographer Gaspar Felix Tournachon, known as 'Nadar', (1820–1910), who is usually credited with taking the first aerial photographs. Negretti claimed that, unlike Nadar, he had taken the first photographs from the air using an untethered balloon (Nadar's well-known views of Paris were taken from a tethered balloon in 1858). There is as yet no known link between the fact that Nadar himself was in London and that his famous balloon was being exhibited inside the Crystal

Palace in the same year that Negretti made his flights – but the coincidence is so remarkable that more connections may yet be found. Given that in England almost no photographs are known to have been taken from balloons until the late 1890s, Negretti's importance is far greater than has previously been realised; yet his photographic fame remains unsung at the Science Museum or any of the national aeronautical or photographic collections. The only evidence we have today are his prolific stereo and portrait photographs and some very collectible scientific instruments.

Negretti and Zambra continued to be associated with the palace for decades, until the end of the 19th century. Their showroom and portrait studio were located near the Ceramic Court. Photographs of a display which is almost certainly Negretti's do exist, showing a stand with a combination of stereo equipment and photographic prints. In 1856, according to *The Times*, Negretti was able to present Queen Victoria with a 'stereotypic representation' of the ceremony celebrating peace in the Crimea before she had even left the building.

The number of stereo views of the palace

produced by Negretti and Zambra probably exceeds 300 and the total number of images produced must be in well in excess of 100,000. The 1856 edition of the *Official Guide to the Crystal Palace* describes Negretti's illustrations of the palace as 'of a kind promising to displace the unsatisfactory prints which of late years have formed the sole questionable ornament for the walls of the working classes'. There was a huge market for stereoscopic views and equipment, so the views of the palace from Negretti and Zambra provide the most common early visual evidence of the palace. They were so prolific in marketing stereo views on an international scale that they not only sponsored one of the expeditions to the Middle East by the eminent photographer Francis Frith but also financed a series of images of China in about 1860 taken by the French photographer Rossier. They must also have had arrangements with their main rival, the other giant stereoscopic source the London Stereo-scopic Company, who produced an entire catalogue of Crystal Palace views.

Negretti and Zambra continued as a company, appropriately supplying aircraft instruments, until they were taken over in 1981 by Western Scientific. After the destruction of its Holborn Viaduct headquarters by bombs in 1941 the company was still operating on Regent Street in 1950, when a short history of the firm was produced. But by then all continuity with the fame of the founder and his role at the Crystal Palace was reduced to a single line engraving of the showroom inside the palace – which almost certainly derives from a now lost photograph taken by Negretti himself.

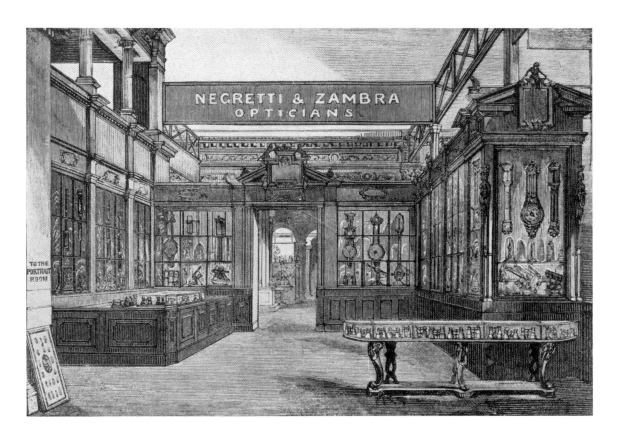

Negretti & Zambra's display inside Crystal Palace
Illustration from Negretti & Zambra company history [see bibliography] almost certainly deriving from a lost original photograph by Negretti. All forms of scientific instruments and photographic equipment were sold including some of the photographs used in this book. The Negretti portrait studio was located nearby.

A Mythical End

HISTORIANS SOMETIMES INDULGE in speculation about how history would have turned out if various lives or events had been different, so it seems appropriate to ask what might have happened to the Crystal Palace had it survived beyond 1936.

If it had managed to survive the V1 and the V2 bombardment of south London (the water towers were destroyed in 1941 so they couldn't act as beacons for enemy aircraft); if it had successfully been 'saved' thanks to John Betjemen's nostalgic pleadings for retention as the 'greatest conservatory in the world'; and if it had overcome the low point of the English conservation movement when the Euston Arch was wilfully destroyed in 1963 – then 2004 would have marked the 150th anniversary of what would have become a grade I listed building. A commemorative event, attended by Queen Elizabeth II, would have been the occasion for much heritage dressing-up and re-enactment, and the brightly lit jewel on the south London horizon would have been visible from the same distant places that witnessed the spectacular night fire of 1936. Both the Crystal Palace railway stations would still be in operation serving new visitors. The palace itself would be the most visited site owned and run by English Heritage (the whole complex was bequeathed in perpetuity to the nation in 1913) and would be the venue for massive musical occasions (including some of the Promenade concerts) as well as other many other events, shows and fairs. An ingenious high-tech sprinkler system would ensure the protection of the historic structure and the surrounding suburbs and park would be a much sought-after conservation area. The park and the palace would be a World Heritage Site with an ongoing programme of restoration of not just the Fine Arts Courts, the gardens and the fountains but also the whole original North End. All the lost statues and sculpture would have been lovingly restored or replaced by replicas, and as the home of the largest collection of sculpture in the country the grounds would regularly see annual sculpture exhibitions. Passengers in aircraft over London and readers of travel brochures all over the world would identify London by the spectacularly lit Crystal Palace, which many would believe to be the original site of the Great Exhibition of 1851.

Instead, and very fortunately for posterity, we do at least possess one of the most superb reminders of an extraordinary building and a dynamic era: the photographs taken by Philip Henry Delamotte. Without his technical facility and artistic eye we would never know the full glory of what we have lost.

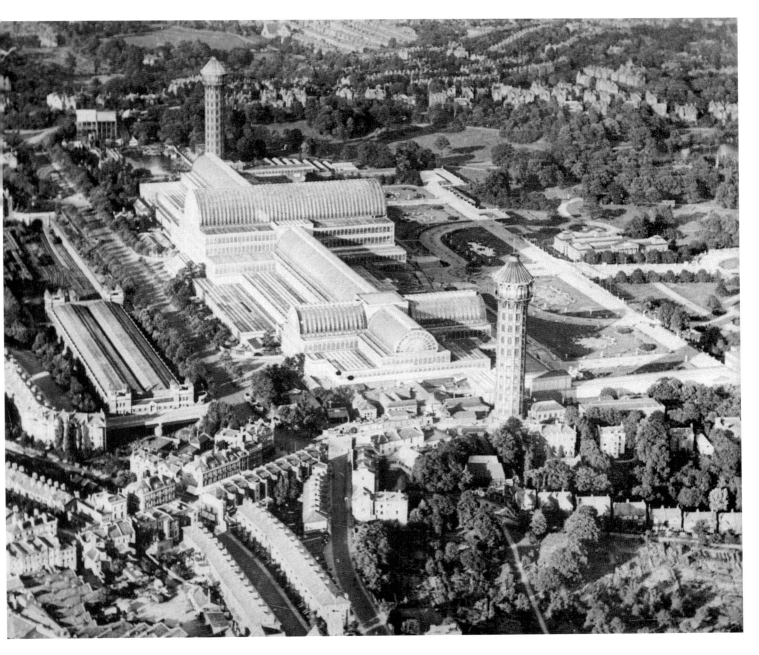

Aerial view from south
A J Mason, c.1925.
The main entrance to the High Level Station is visible on the left. After the 1936 fire which destroyed most of the palace, the water towers and the station were demolished in the 1940s and 1950s.
[AA63/2545]

PLATE XX

Greek ornament
from Owen Jones's
*The Grammar of
Ornament*, 1856.

The Delamotte Collection

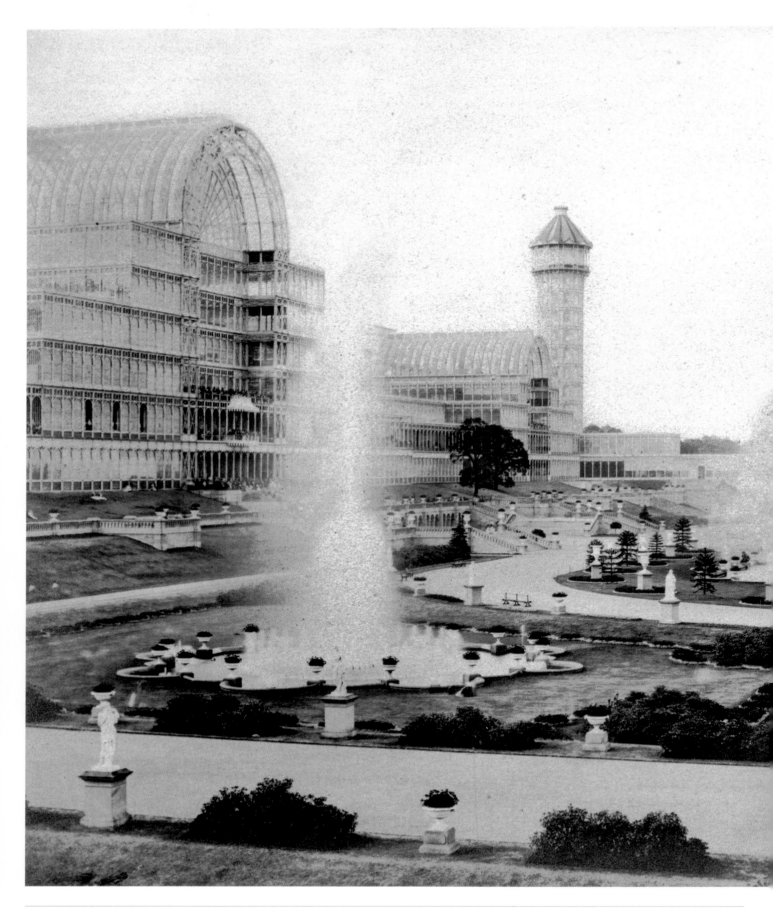

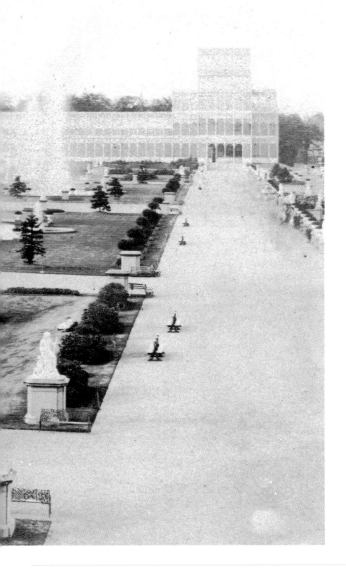

Garden Front
Delamotte c.1859.
The Upper Terrace fountains are in operation and a large group is visible on the balconies underneath the Central Transept. In windy conditions the fountains must have been worth avoiding, which may account for the lack of visitors on the paths.
[DP004602]

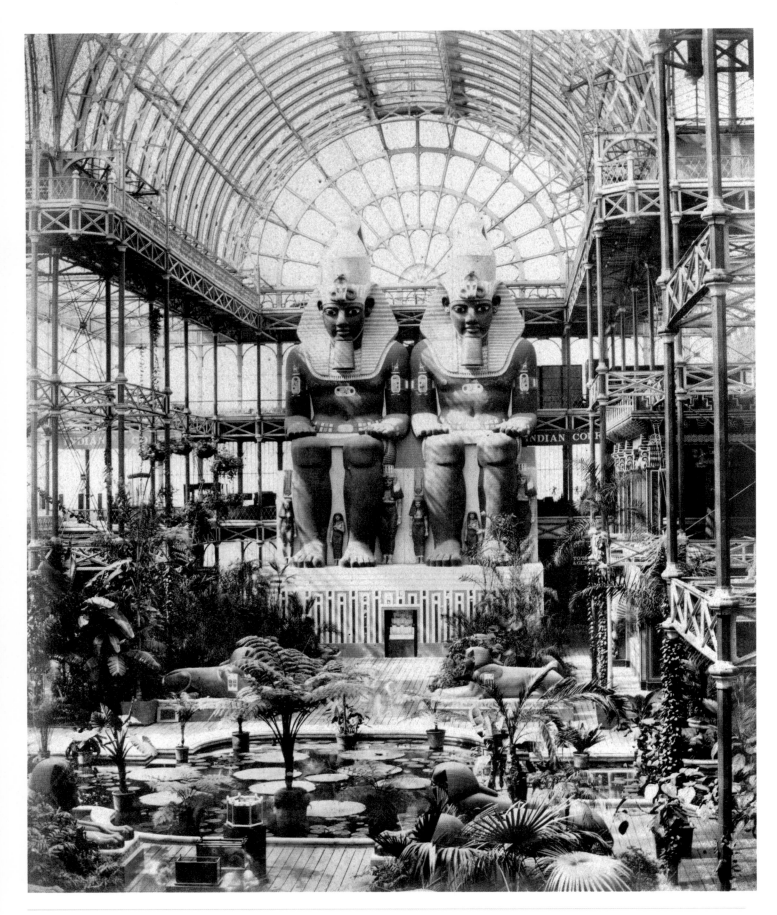

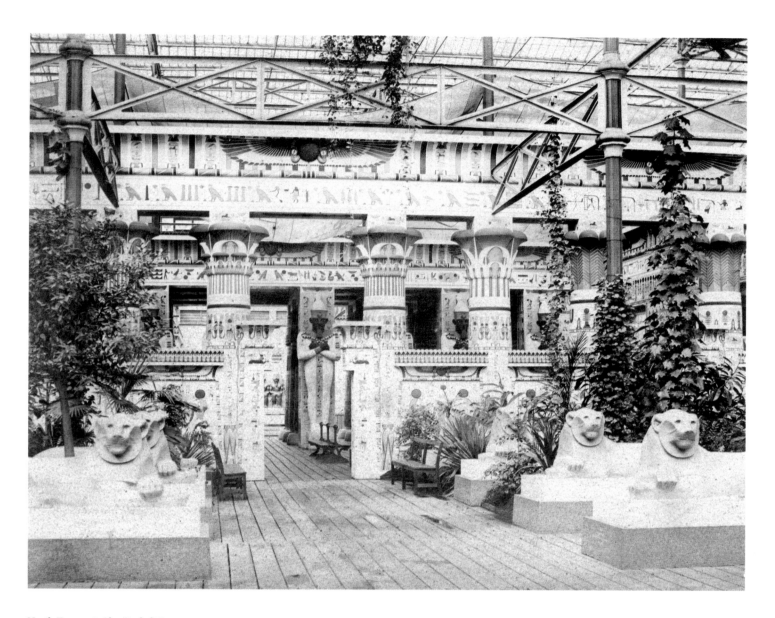

North Transept: Abu Simbel Figures
Delamotte c.1859.
*The reduced but still giant figures by
Owen Jones were destroyed in the
1866 fire. Standing 70 feet high they
successfully conveyed the scale and the
design of such antiquities to a new
popular audience. Note the little-
known Indian Court behind. There
were many minor or temporary or
industrial 'Courts' apart from the
famous ten called the Fine Arts Courts.
[DP004613]*

Egyptian Court
Delamotte c.1859.
*Owen Jones's ability to adapt
archaeological accuracy within a
modern structure is strikingly
evident. Note the sun-blinds in the
roof above: the amount of light must
have been overwhelming - until
dusk. The palace pioneered Edison's
electric lighting later in the century.
[DP004619]*

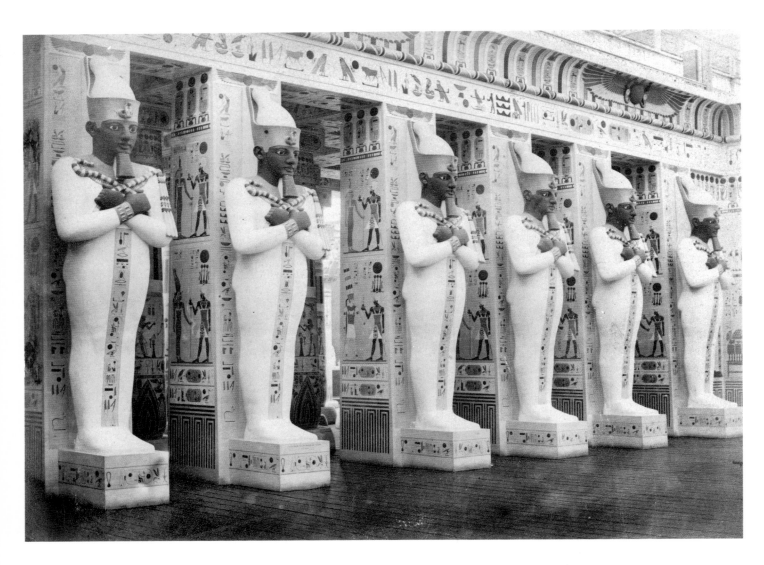

Egyptian Court

Delamotte c.1859.

Though accurate, the hieroglyphic inscriptions also conveyed messages about how this new palace of a thousand columns, a thousand statues and a thousand trees was built by architects, painters and sculptors as a book for the instruction of all men and women.

[DP004620]

Nineveh Court

Delamotte c.1859.

The huge winged bulls were very novel having only been excavated by Sir Henry Layard in the 1840s. Layard helped to design the Court but few views are known of the interior which can be glimpsed above: it had a vibrant polychrome decorative scheme designed by Owen Jones. Delamotte allows our eyes to be drawn towards one the many Piranesian vistas which are both natural and prefabricated, historical and abstract. The palace attained a unique synthesis of art and engineering: later Victorian buildings like railway stations were deliberately clothed with polite exteriors and very few structures were allowed to expose the new industrial materials.

[DP004617]

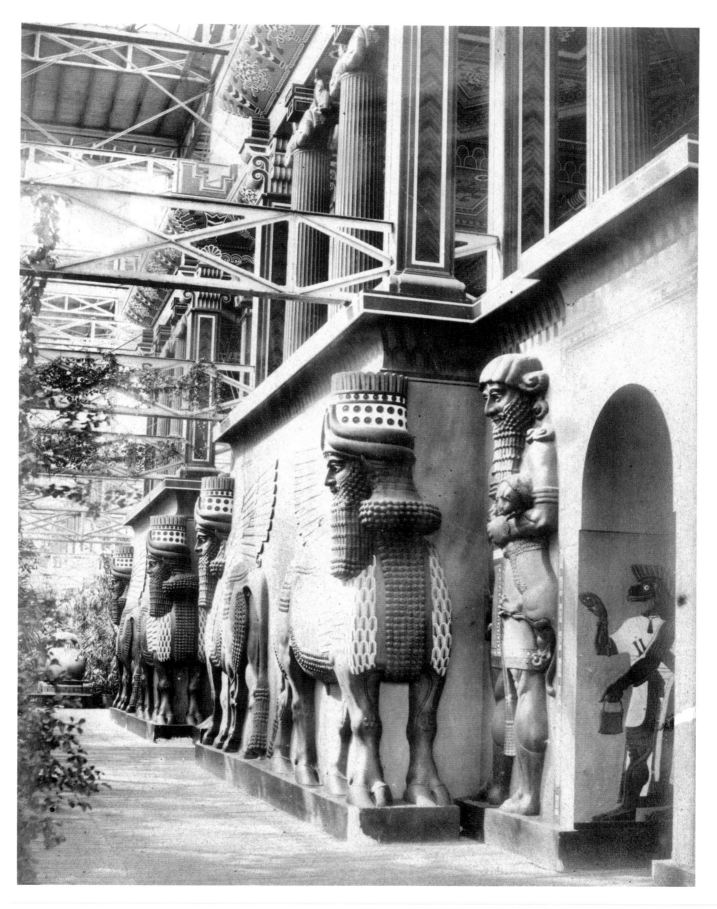

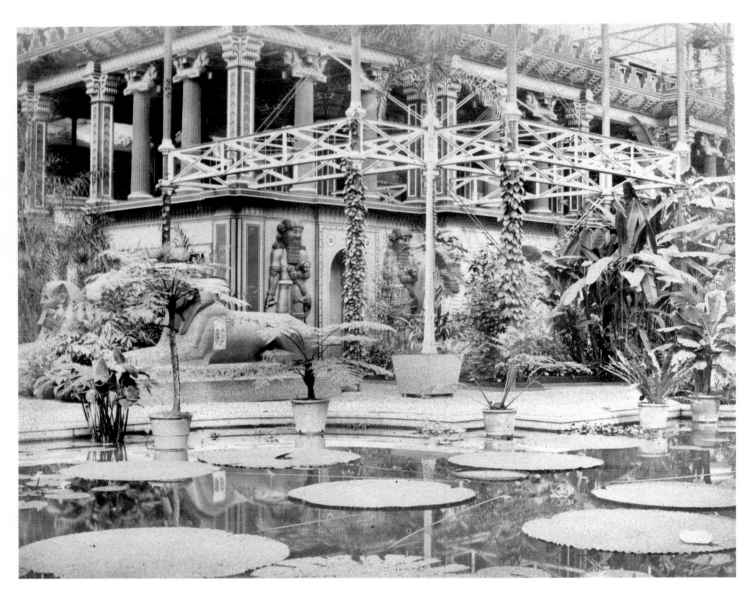

Nineveh Court
Delamotte c.1859.
In the foreground are examples of
the large lilies which Paxton
famously cultivated at Chatsworth.
Fronds and leaves of tropical plants
are here not allowed to hinder the
horizontal discs of the lilies which
were exotic attractions in
themselves.
[DP004616]

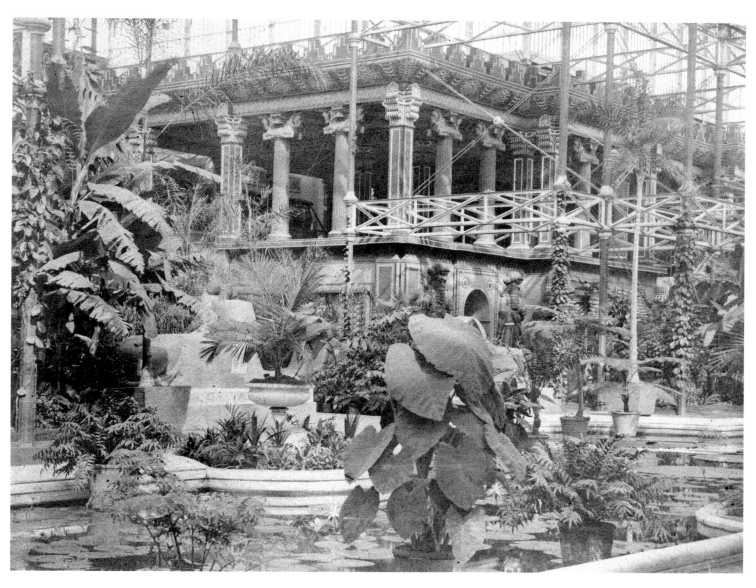

Nineveh Court
Delamotte c.1859.
Delamotte allows the tropical foliage
to obscure the Egyptian sphinx
behind the pool.
[DP004614]

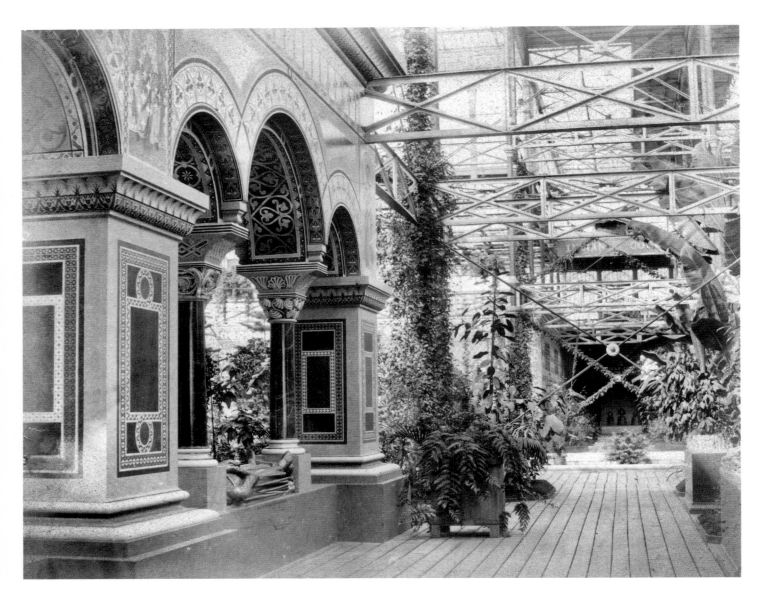

Byzantine Court
Delamotte c.1859.
The effigy of Richard Coeur de Lion under the arches contrasts with another perspective conceit : for visitors the combinations of interior views must have been dazzling.
[DP004627]

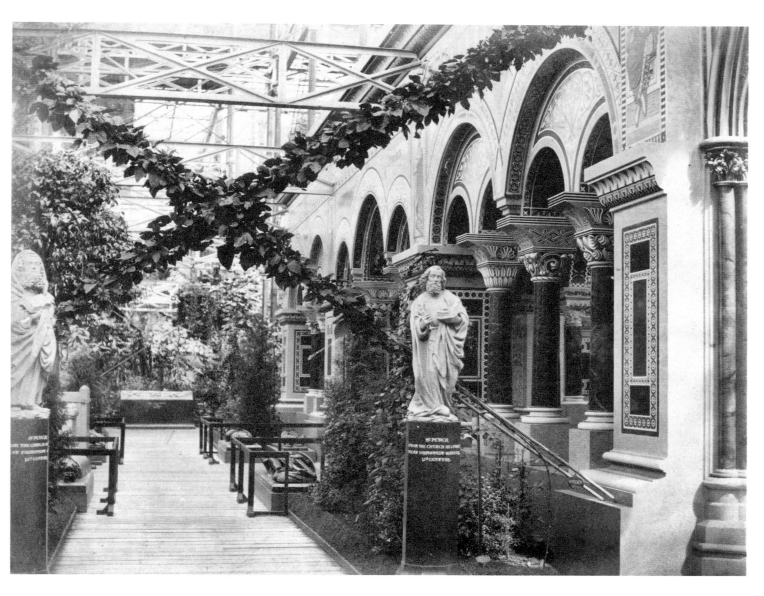

Byzantine Court
Delamotte c.1859.
The statues of St Peter and the cloister behind come from a concerted campaign to acquire casts from all over Europe. Again the braced diagonals are used as an effective compositional device as well as acting as a warning to visitors.
[DP004628]

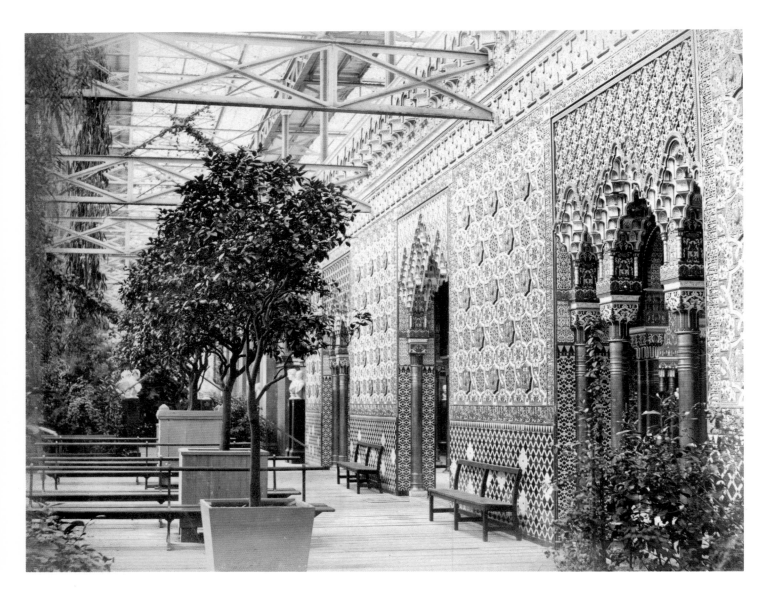

Alhambra Court
Delamotte c.1859.
*The 'contradiction' between the honest
structure and the fantastic Moorish
surfaces does not affect the appreciation
of both. Today such a mixture is only
being rediscovered – perhaps the closest
parallel to the Crystal Palace is the
astonishing conjunction of an original
Adam room sitting inside Richard
Rogers' Lloyds building in the City of
London – the exterior of which
deliberately echoes the transept of the
palace.*
[DP004624]

Alhambra Court
Delamotte c.1859.
*Owen Jones's faithful interpretation of
the Alhambra was based on the most
thorough study of the building ever
made: his records are still definitive but
we must note that what was replicated at
the Crystal Palace was an interpretation
to fit a given space. However, the author
George Eliot visited both and is known to
have commented that the original in
Granada was "vastly inferior to the
work of Owen Jones"!*
[DP004625]

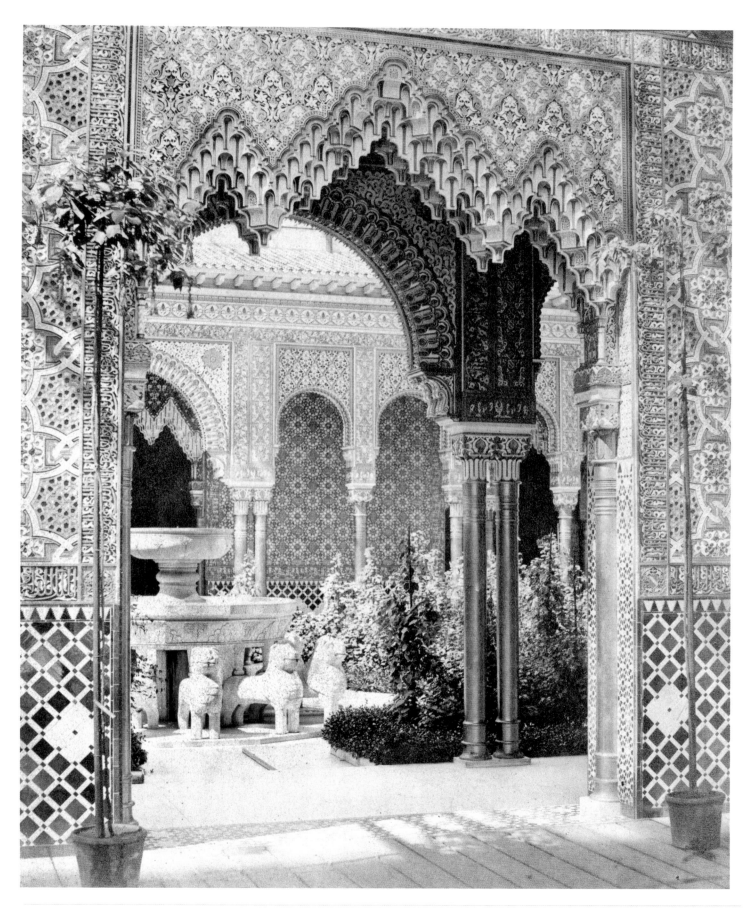

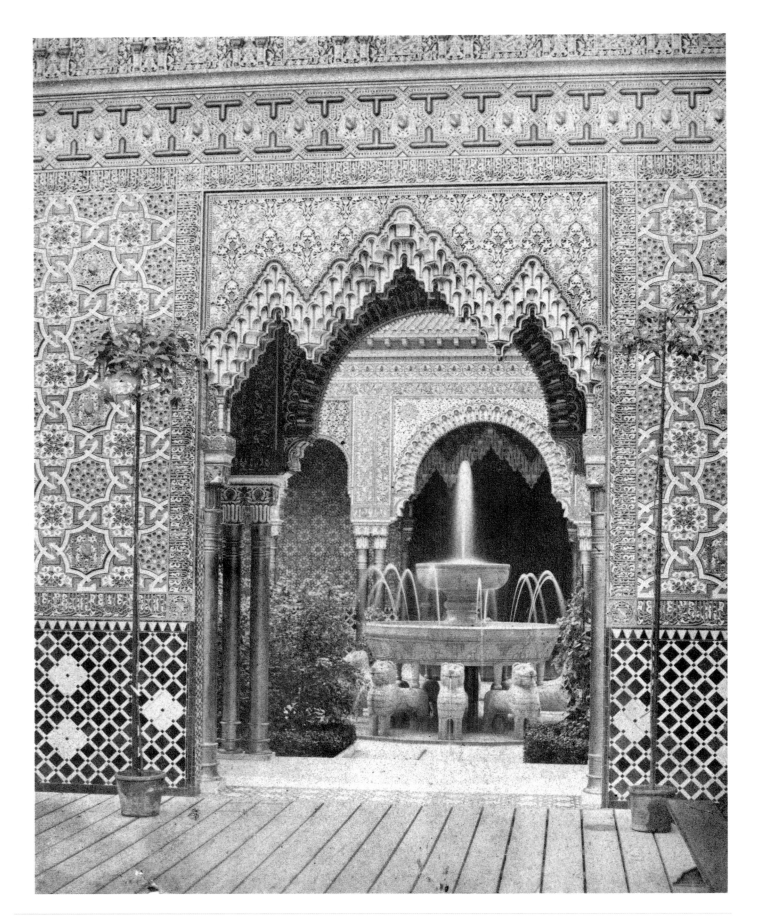

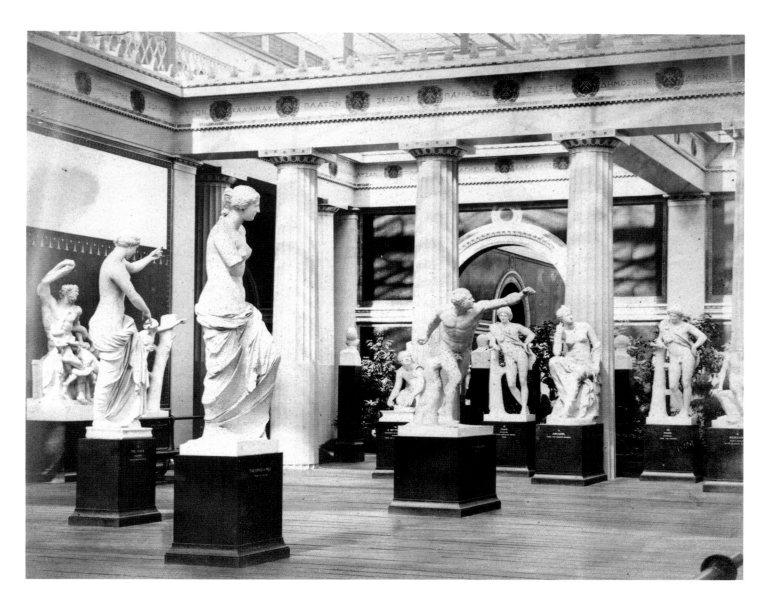

Alhambra Court

Delamotte c.1859.

The fountain plays in the Court of Lions: the lions were created by the sculptor Raphael Monti who is associated with a whole series of pieces at the palace. Some idea of the effect of the intricate coloured detail of the surfaces can be gained by studying Owen Jones's plate from his Grammar of Ornament but no records survive to accurately show one of the best examples of Victorian polychromy ever created – the fact that the Pre-Raphaelite painter William Holman Hunt used the court as a back-drop to one of his paintings acts as a reminder that many other painters and designers were influenced by both the exterior and the fantastic choice of ornament inside.

[DP004626]

Greek Court

Delamotte c.1859.

The palace exhibited an almost complete anthology of classical and other sculpture which is only distantly echoed in the Cast Courts of the Victoria and Albert Musuem. Though mostly copies, some original sculpture was also in evidence. In effect this was a key reference collection which had been carefully selected and copied by Owen Jones and T H Wyatt. In the foreground is the Venus de Milo *from the Louvre, Paris.*

[DP004621]

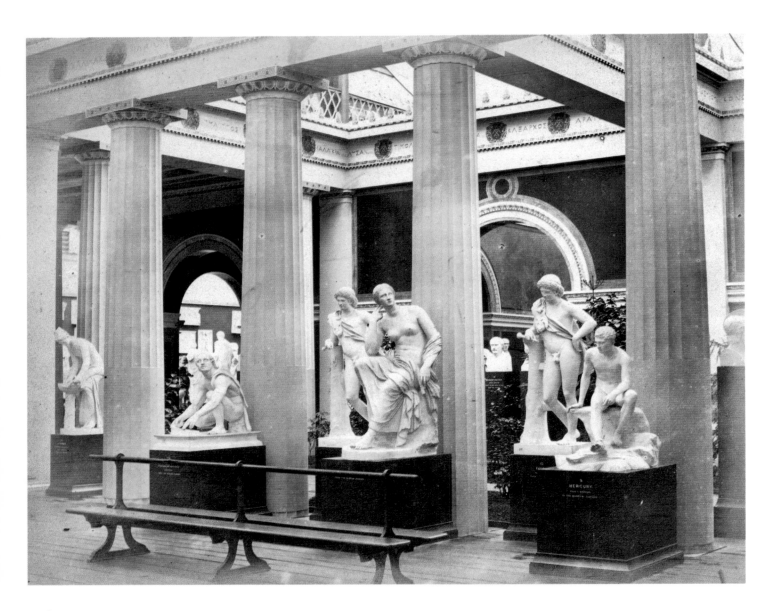

Greek Court
Delamotte c.1859.
The Gallery of Antique Sculpture
[p73] is visible on the left. The
numbering and cataloguing of the
sculpture presented problems even at
the time since pieces were
continually moved. An entire
detailed catalogue exists of every
piece of what would have been the
largest sculpture collection ever
assembled in Great Britain.
[DP004622]

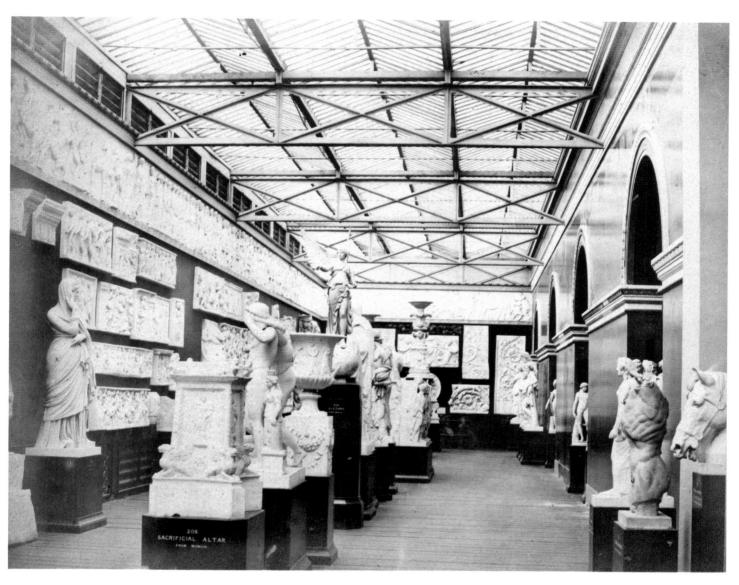

Gallery of Antique Sculpture
Delamotte c.1859.
Located just beyond the Greek Court, the collection of reliefs and casts was erected before any equivalent at the Victoria and Albert Museum. A few pieces were transferred to the V & A before the 1936 fire but most were destroyed.
[DP004623]

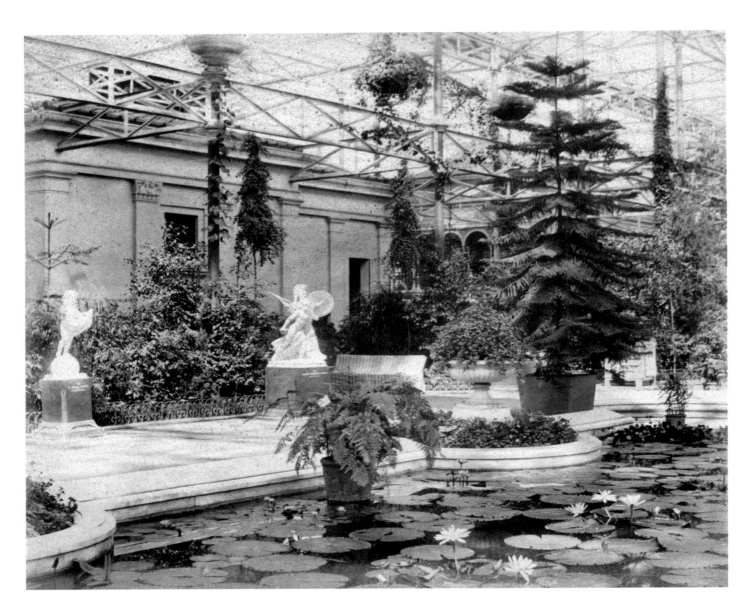

Pompeian House
Delamotte c.1859.
Designed by T H Wyatt, this style of décor had become popular in England though Owen Jones's student Christopher Dresser thought that "Pompeian art was false, and Pompeii was destroyed", explicitly linking the decadent décor with destruction.
[DP004641]

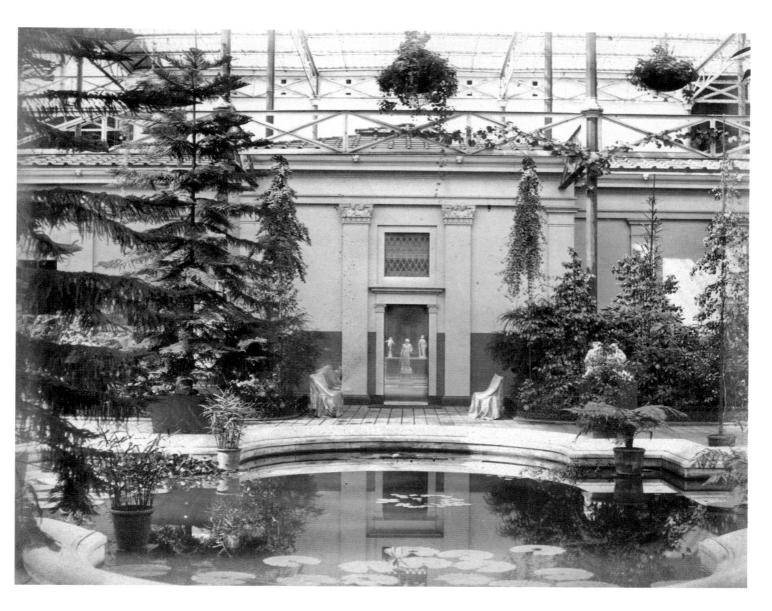

Pompeian House
Delamotte c.1859.
*Note the authentic roof tiles under the
iron prefabrication. The authority on the
second palace, Jan Piggott, points out that
"The Court, not surprisingly, stimulated
thoughts of food and the pampered body,
and the Crystal Palace Hairdressers and
Atkinson's perfumery were close by".
We have to be reminded that the palace
was full of such useful and fashionable
attractions and that almost no
photographer has recorded any of this
hidden shopping mall.*
[DP004642]

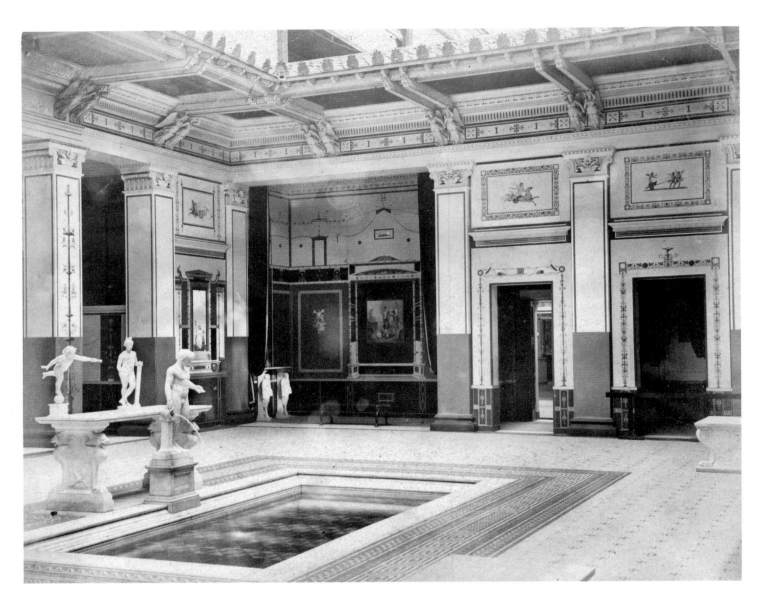

Pompeian House
Delamotte c.1859.
*With an authentic open atrium this
was the location for a lunch served
to Queen Victoria and Prince Albert
during one of their visits to the
palace.*
[DP004643]

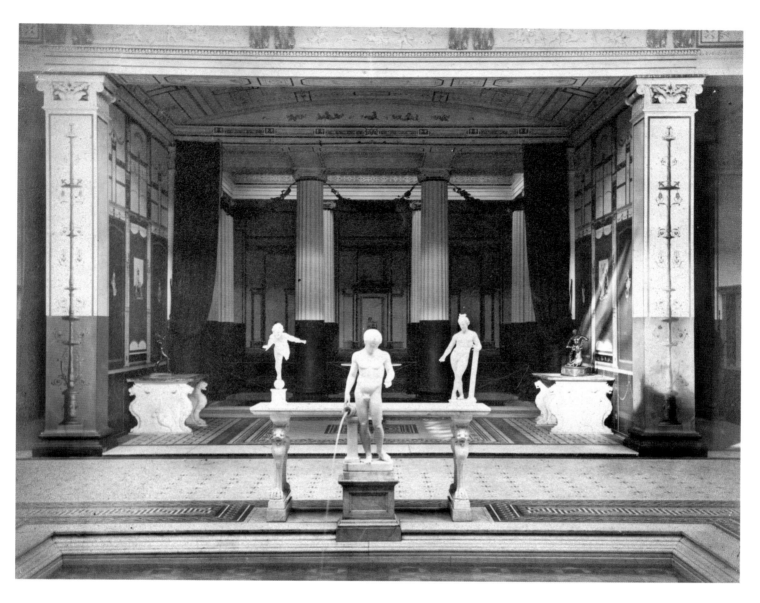

Pompeian House
Delamotte c.1859.
Accounts of the colour scheme
suggest that it was not as authentic
as it could have been: this was the
design of T H Wyatt and Owen Jones
was known to be cool about the
virtues of Roman decoration.
[DP004644]

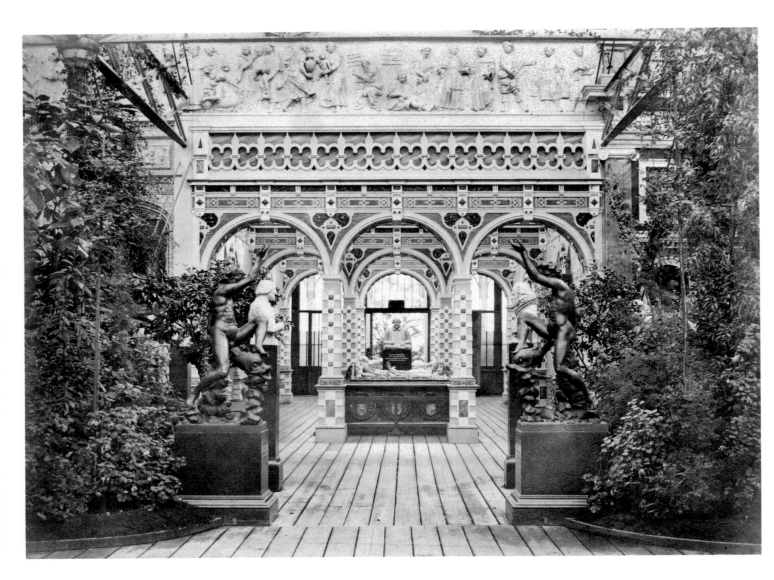

Elizabethan Vestibule
Delamotte c.1859.
Between each of the main Fine Arts Courts were subsidiary intermediate 'Vestibules'. The design of the Elizabethan Vestibule was based on Holland House in west London. Note the bust of Shakespeare in the centre.
[DP004638]

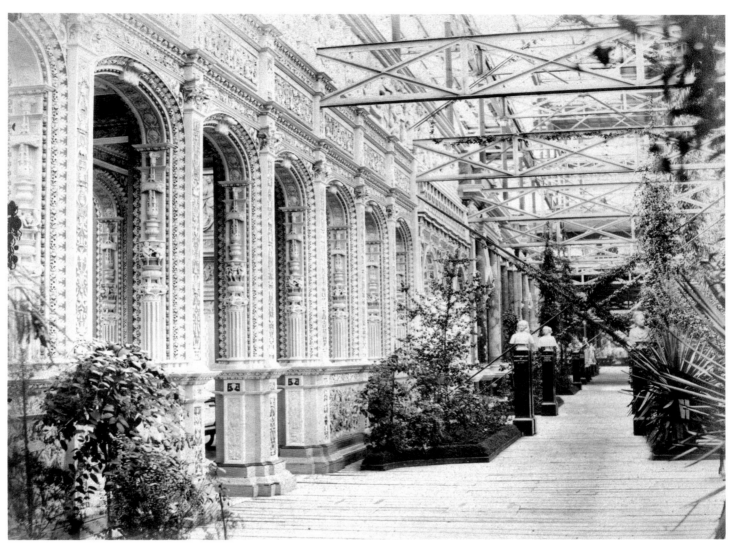

Renaissance Court
Delamotte c.1859.
The arcade around the Court derived from
the Hotel de Bourgtheroulde at Rouen and
was made by M Desachy of Paris.
[DP004637]

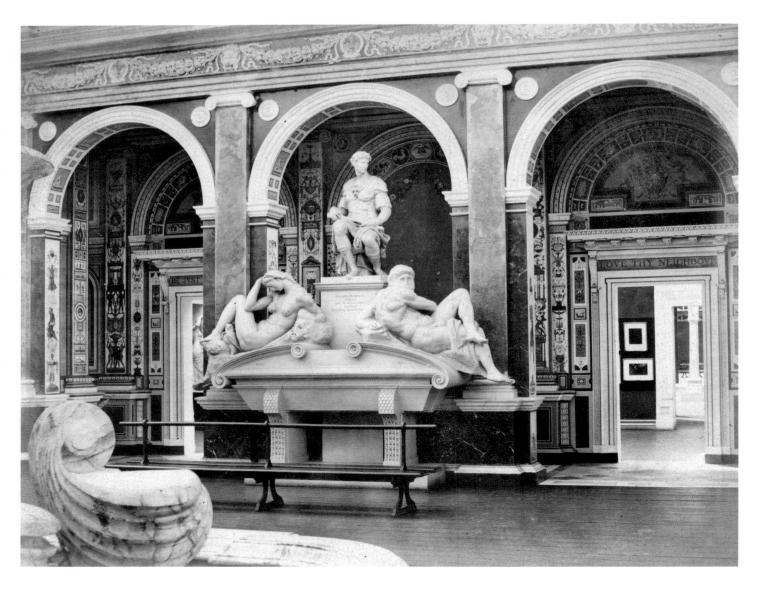

Italian Court
Delamotte c.1859.
*An homage to Raphael and
Michelangelo*
[DP004639]

Fountain of the Syrens
Delamotte c.1859.
*Standing outside the Nineveh Court the
large fountain depicted the continents. The
sculptor was Raphael Monti [1818–81]
who was used for a number of pieces inside
and outside the palace (see p41) for one of
the very few surviving pieces of sculpture].
The fountain was destroyed in the fire of
1866. Note the bird-cage on the right:
the North or Tropical end of the palace was
populated not only by free-flying parrots but
also by other animals that perished in the
1866 fire.*
[DP004615]

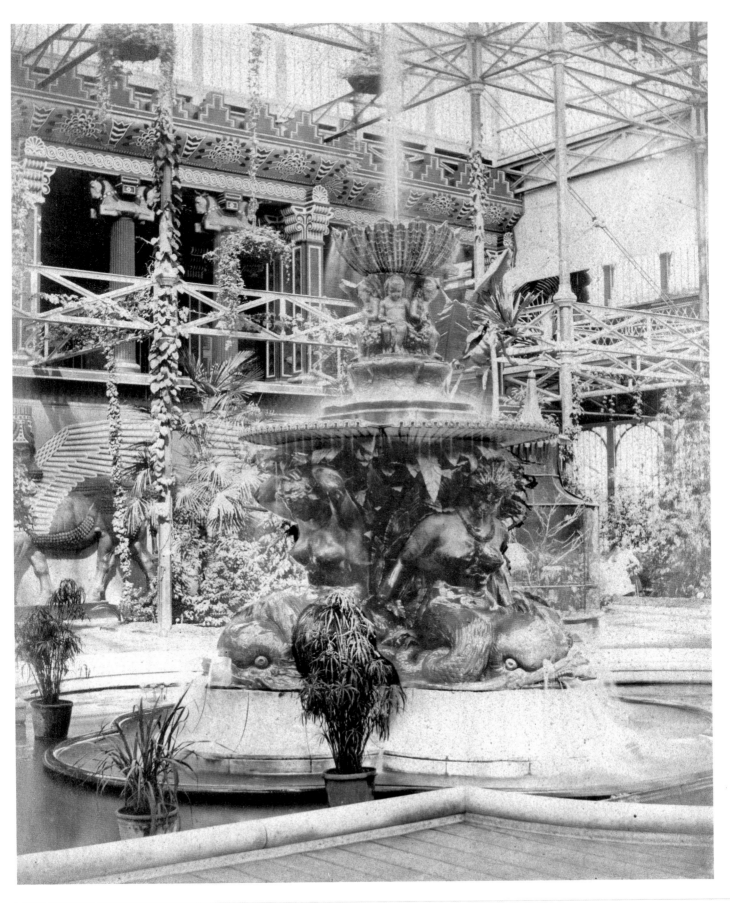

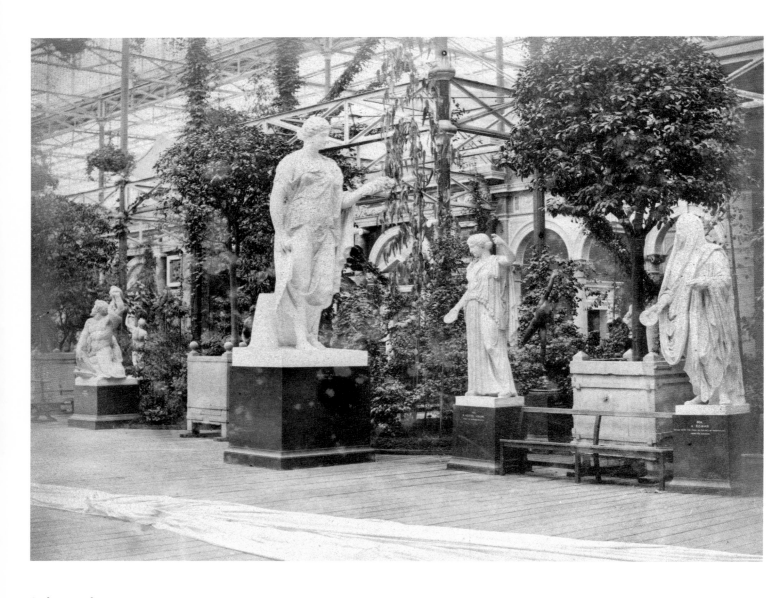

Sculpture in the Nave
Delamotte c.1859.
Owen Jones and T H Wyatt spent months in Europe collecting a representative series of pieces from Paris, Naples, Dresden, Berlin and other famous galleries. They intended to place a copy of one of the Egyptian obelisks from Rome in the palace but were refused permission by the Pope.
[DP004608]

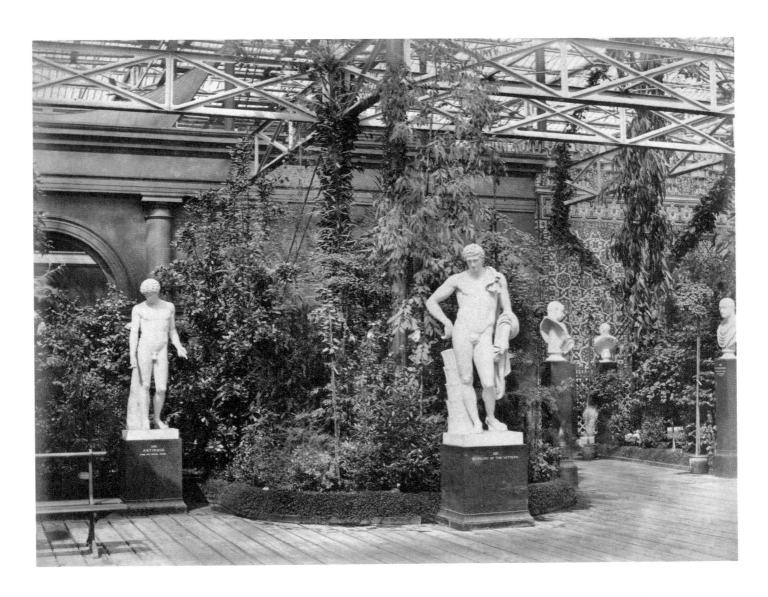

Sculpture in the Nave
Delamotte c.1859.
*The proprieties of displaying figures
without fig-leaves exercised the Crystal
Palace Company, who had to bow to
public pressure. Similar problems with
temperance and religious groups meant
that the selling of alcohol and Sunday
opening were issues in the early years and
though by the end of the century the
palace held one of the best wine and beer
cellars in the country, the argument that
this was a people's palace was not
sufficient for the allowance of Sunday
opening.*
[DP004609]

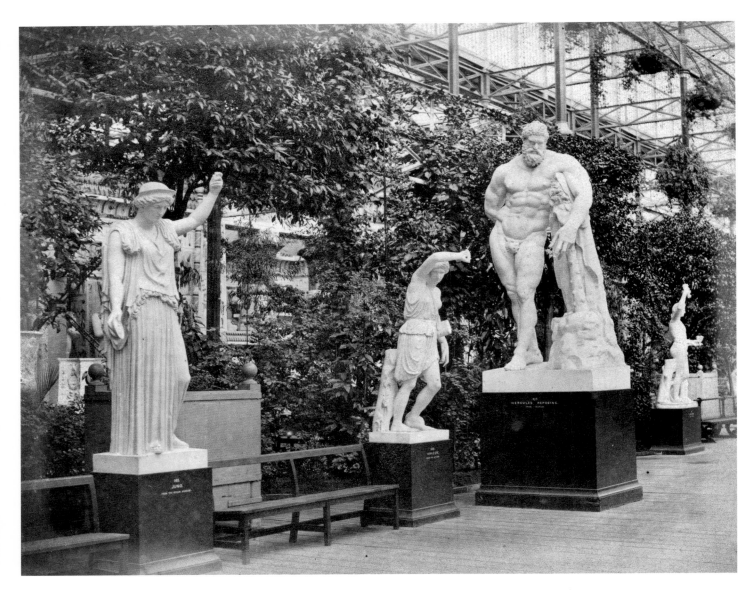

Sculpture in the Nave
Delamotte c.1859.
In later years there were several
attempts to create a national collection
of sculpture in the Crystal Palace.
In effect the nucleus of such a
collection already existed in Sydenham
which certainly had the space for such
an enterprise. No decision was made
and the fire of 1936 destroyed more
than 90% of the sculpture. All
remaining pieces were sold by the
LCC after the Second World War.
[DP004610]

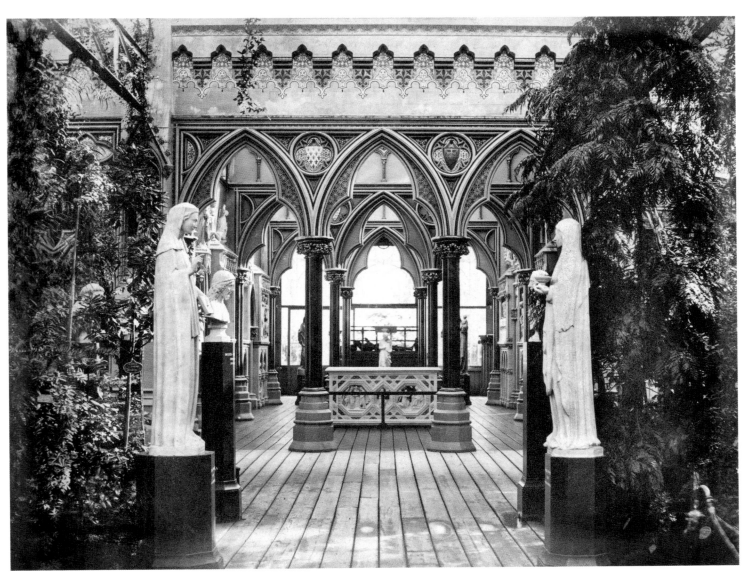

Medieval Vestibule
Delamotte c.1859.
Designed by T H Wyatt this and the Medieval Court were heavily influenced by the recently deceased A W N Pugin who had been an unwilling collaborator at the Great Exhibition: his focus on the Gothic would soon dominate architectural taste and preclude the possibilities shown by glass and iron prefabrication. In England, unlike France there was little exploration of combining iron prefabrication with the Gothic.
[DP004632]

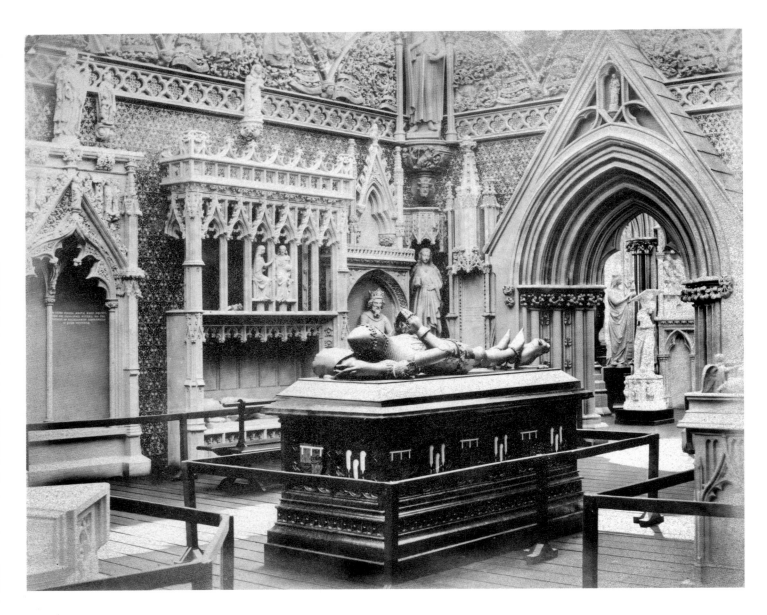

Medieval Court
Delamotte c.1859.
One of the few historical displays at
the Great Exhibition in 1851 had
been a similar Medieval anthology of
actual and new Gothic designs by
A W N Pugin. T H Wyatt designed a
similar Court for Sydenham. The
effigy is that of Edward the Black
Prince from Canterbury Cathedral.
[DP004633]

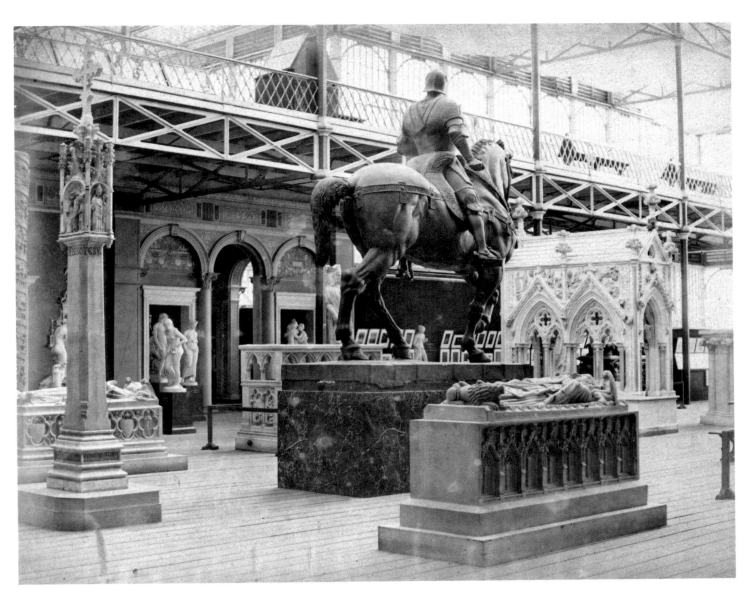

Central Transept
Delamotte c.1859.
*Titled the 'Court of Christian Art', by
1857 this area was very soon dedicated
to music with the erection of the organ
and the vast choir seating (see pp4
and 8). An eclectic series of English
and Continental icons of art history
were initially situated here. Note the
copy of Canova's* Three Graces *between
the cross and the equestrian statue of
Colleone by Verrocchio. Note also the
display of paintings or photographs
between the legs of the horse.*
[DP004629]

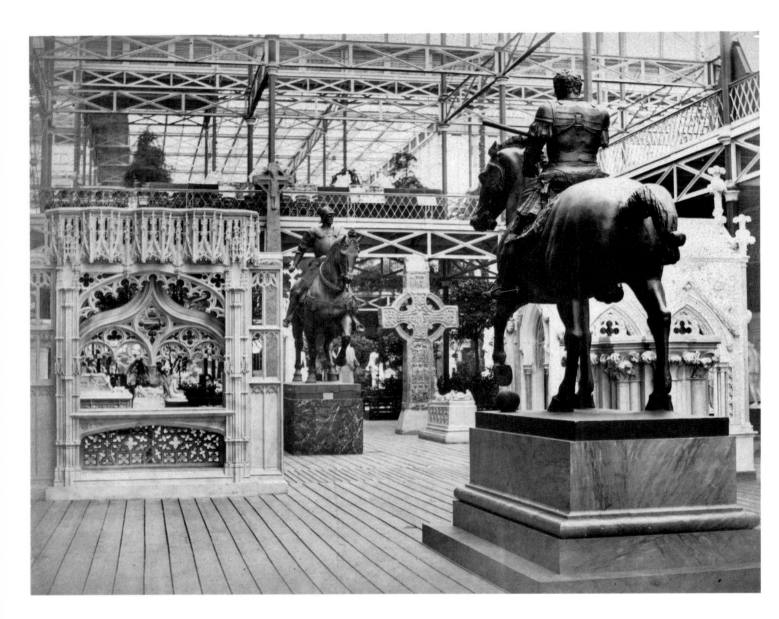

Central Transept
Delamotte c.1859.
*Copies of the equestrian statues of
Colleone (by Verrocchio) and
Gattamelata (by Donatello) were
placed among other casts of English
and Irish monuments. The Gallery
above also had displays – but records
for very few of these are known to
exist.*
[DP004630]

Garden Gallery
Delamotte c.1859.
The Gallery was situated on the
East side of the Fine Arts Courts and
reflecting the adjoining Courts – in
this case the Medieval Court. Most of
this was destroyed by the 1866 fire.
[DP004634]

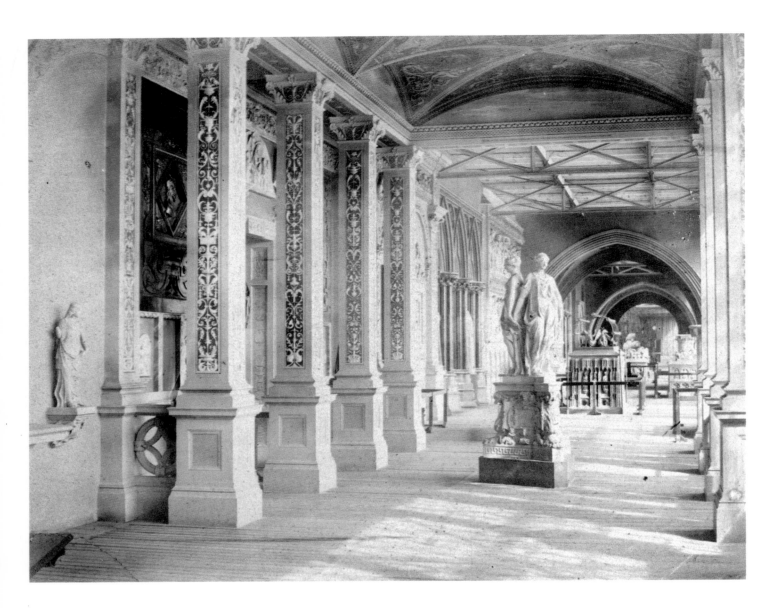

Garden Gallery
Delamotte c.1859.
One side of the Renaissance Court
is visible along with a version of
The Three Graces *by Pilou.*
[DP004635]

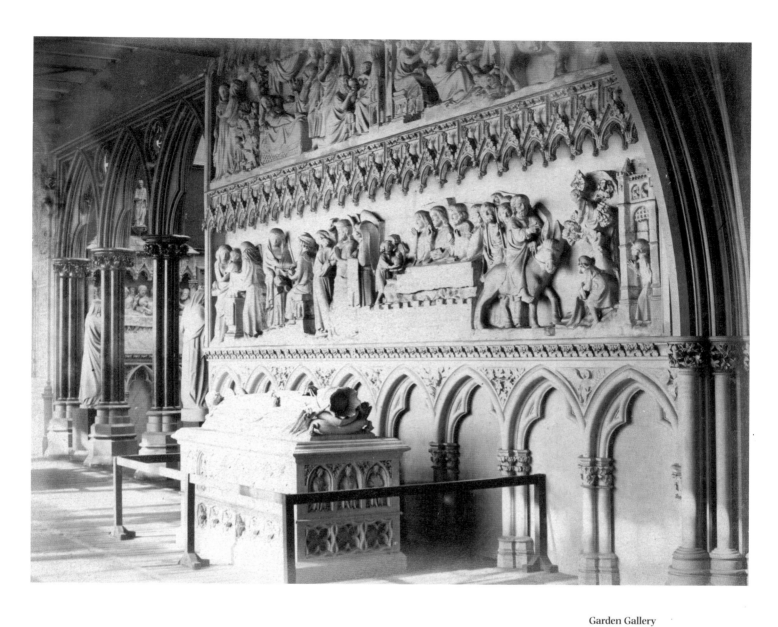

Garden Gallery
Delamotte c.1859.
Near the Medieval Court was a very elaborate relief from the choir of Notre Dame Cathedral in Paris.
[DP004636]

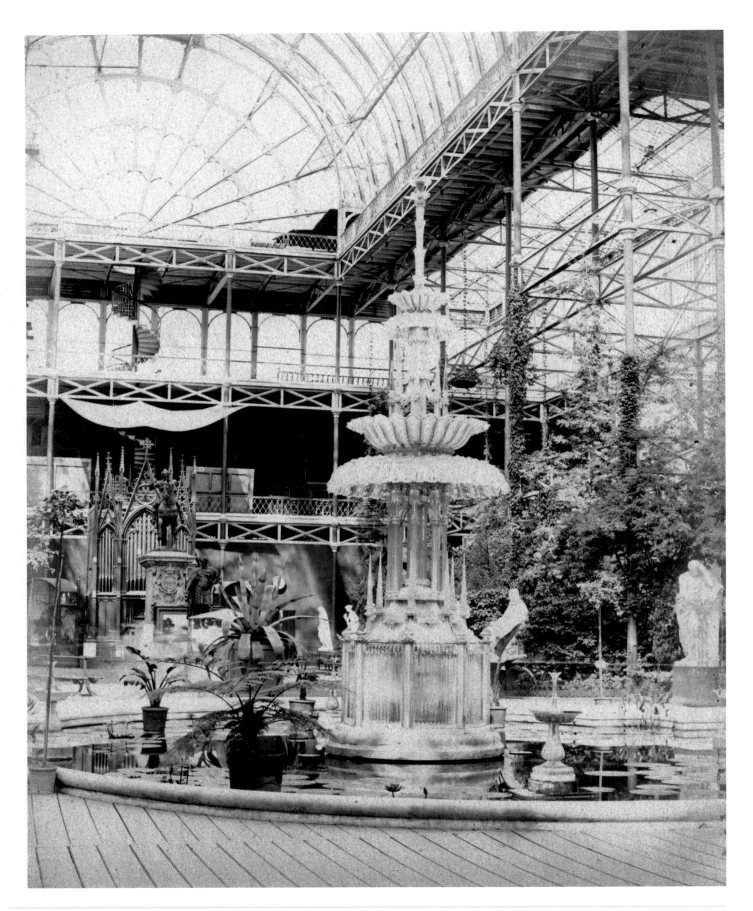

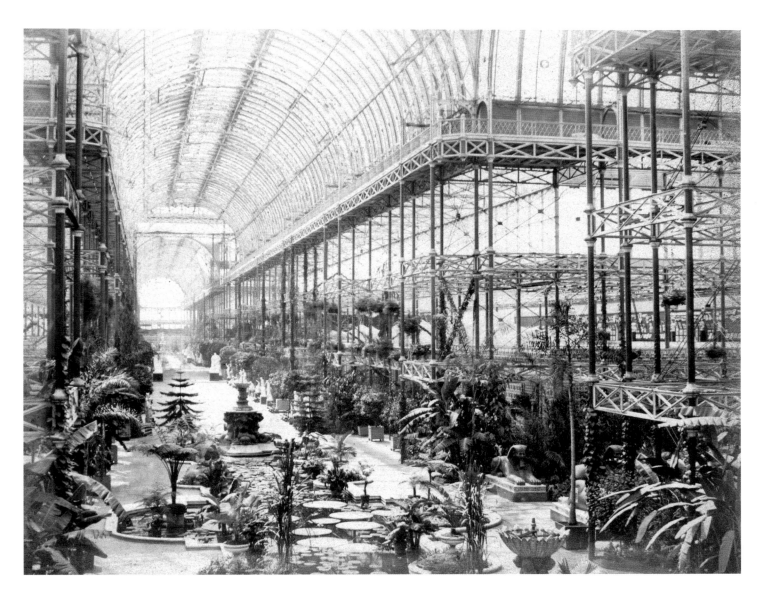

South end of the Nave
Delamotte c.1859.
The Osler or Crystal Fountain was made in Birmingham for the Great Exhibition. Behind it can be seen the diminutive organ which was replaced by the much larger instrument in the Central Transept. In the shadows above it is the well-shaded Picture or Portrait Gallery. The screens behind the organ probably hide the extensive refreshment rooms which like all business activities in the palace are almost completely unrecorded.
[DP004640]

North End of Nave looking south
Delamotte c.1859.
The pair of Egyptian figures are on the right and the Monti fountain is in the centre foreground. Throughout Delamotte's output there is little evidence of the extensive screening required for light and temperature which would have been necessary for the contents and for the visitors. It is possible that he made sure that these extraneous details were deliberately removed for his photographs. He certainly avoided any such intrusions even if they were actually in place.
[DP004607]

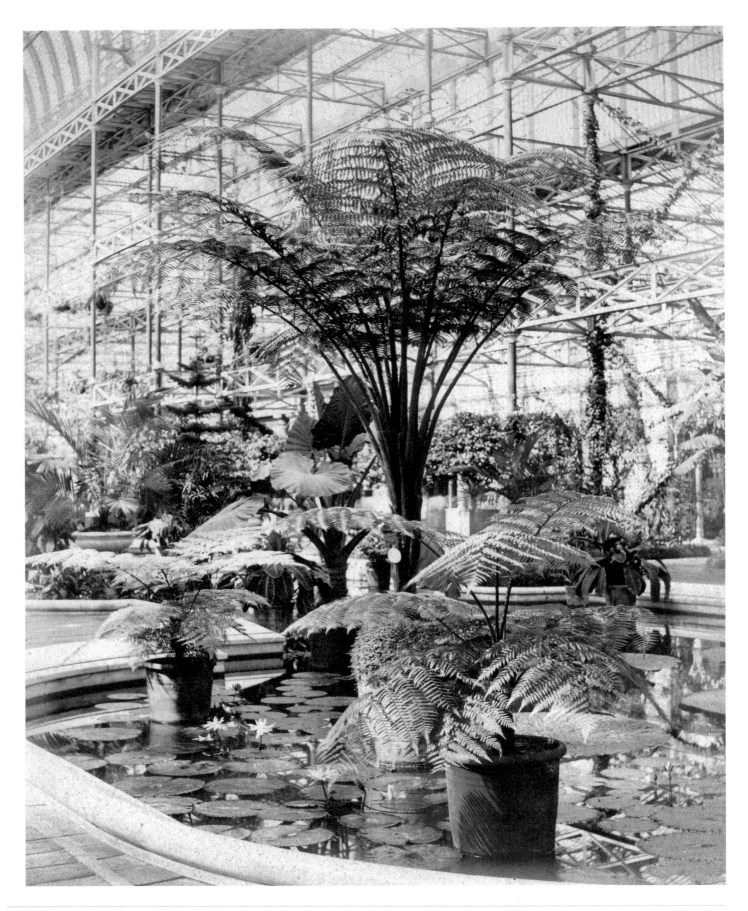

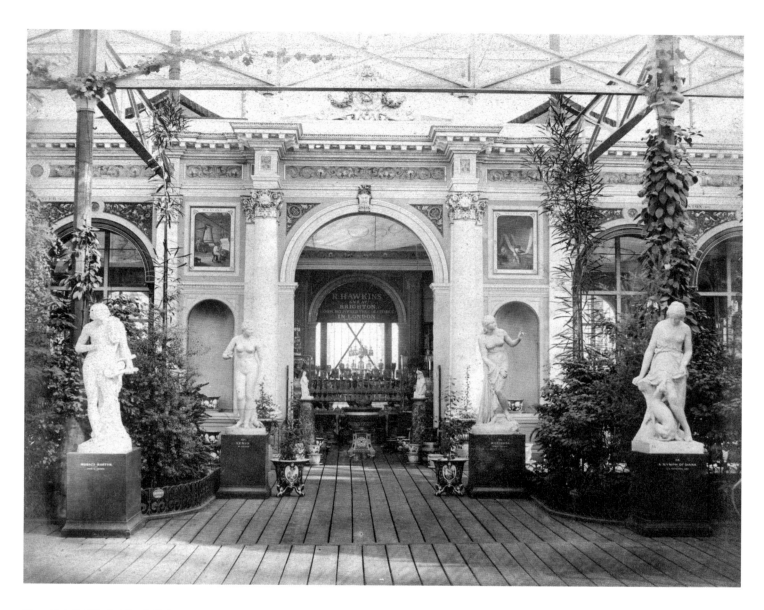

Nave: Detail of Pool at North End
Delamotte c.1859.
The vegetation and planting became
more lush and tropical as one
walked towards to the north. The
Victorian obsession with plants,
especially ferns and palms, was
informed by Paxton's extensive
experience at Chatsworth.
[DP004611]

Manchester Court
Delamotte c.1859.
Situated within the short-lived Industrial
Courts in the southern part of the Nave,
the Manchester Court revealingly
includes an extensive display of items
for sale by 'R Hawkins' of Brighton and
London. Such displays were common but
photographs of them are very rare.
The panels either side of the arch display
paper-making by cherubs.
[DP004645]

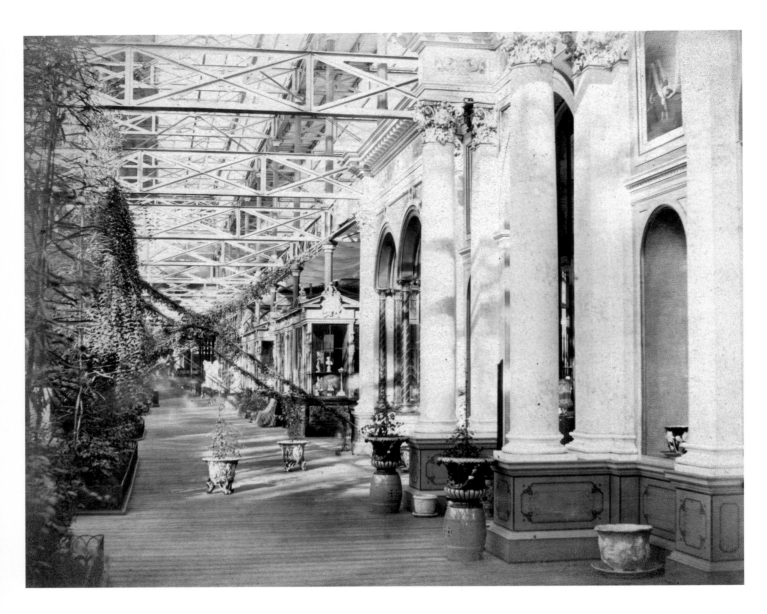

Ceramic Court
Delamotte c.1859.
*Next to the Manchester Court a
display within elaborate classical cases
may show valuable items on a loan
exhibition. Delamotte presumably
wished to break up the long floor space
with carefully located urns which
would not usually have been left in
this position.*
[DP004646]

**The Rosery or Rosarium with the
South Wing and Water Tower**
Delamotte c.1859.
*A very deliberate composition
framing the buildings and providing
a figure for scale. The filigree detail
by Owen Jones is not unlike the
distinctive style of the Festival of
Britain in 1951. The Rosarium was
replaced by a purpose-built
Panorama building in 1881.*
[DP004605]

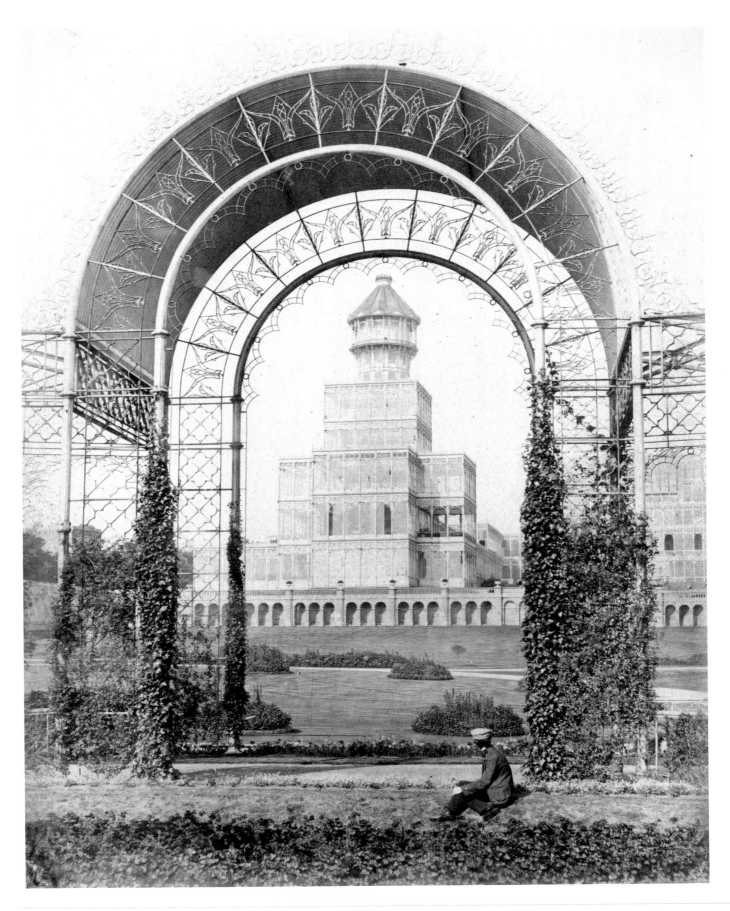

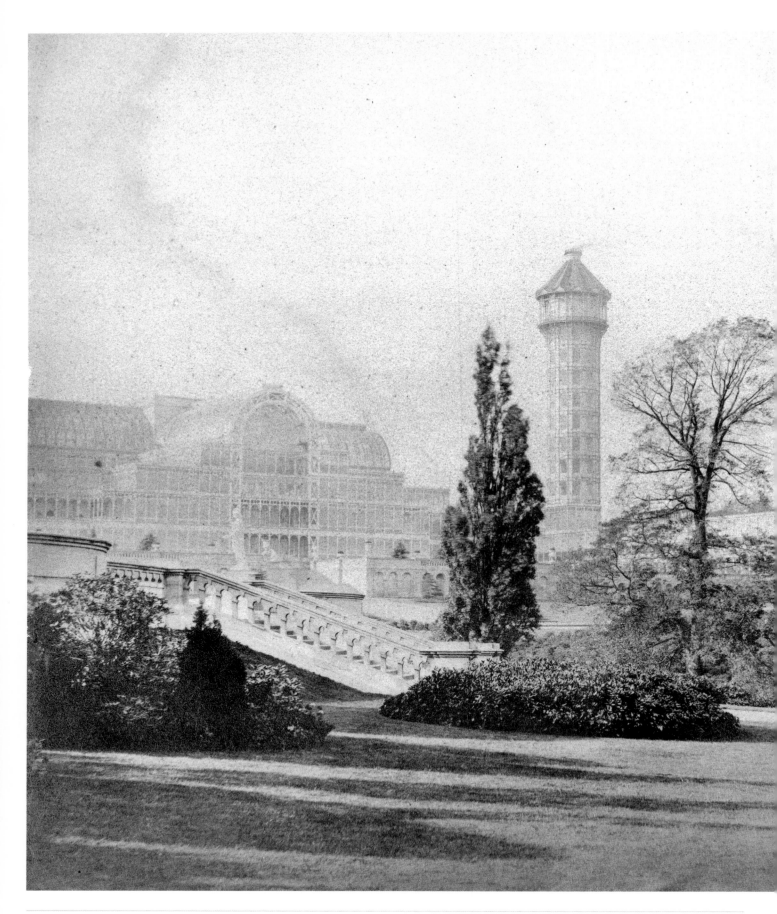

Northern End from south east
Delamotte c.1859.
Apart from the water tower all the buildings were either blown down in a gale or destroyed by fire in 1866. This view today would only show the BBC television mast. The picturesque landscaping should be contrasted with the formal garden layout closer to the palace. The vast effort in providing water for the fountains was soon nullified and only parts of the planting now survive though the application of modern archaeological techniques could replicate one of the most elaborate landscapes ever designed – which is now owned by the nation.
[DP004604]

Pompeian ornament from Owen Jones's *The Grammar of Ornament*, 1856.

APPENDIX
List of Exhibitors

Introduction to Appendix

This List of Exhibitors appeared in the 1854 *Guide to the Crystal Palace and Park* by Samuel Phillips.

For photographers other than Delamotte and Negretti see the West Gallery 'Department for Philosophical Instruments' (p173 of the List).

The list includes a number of businesses still operating in 2005, including Stanford's (maps), Letts (stationery), Mappin (silver), Chubb (locks), Prices's (candles), and Rimmel (cosmetics).

LIST OF EXHIBITORS.

————◆————

STATIONERY AND FANCY GOODS COURT.

BIRMINGHAM COURT.

Parker, W., Jewellery, Gilt Toys, Masonic, and other Ornaments .

Peyton and Harlow, Patent Metallic Bedsteads

Sutton and Ash, Specimens of Manufactured Iron . . .

Timmins and Sons, R. . . .

Warden and Co., J. . . .

SHEFFIELD COURT.

Addis, S. J., Carvers' and General Edge Tools

Butterly, Hobson, and Co., Scales, Scythes, &c.

Cammell and Co., C., Springs, Steel, Files, &c.

Cocker, Bros., Sheffield Tools, and Mechanical manufactures .

Fisher and Bramall, Specimens of Iron and Steel, Tools, &c.

Guest and Chrimes, Various Patent High Pressure and Fire-cocks, &c.

Jowett, T., Various kinds of Files,

and specimens of the manufacture of Steel

Mappin and Bros., J., Cutlery; Silver and Electro-plated goods; Dressing-cases . . .

Nowill and Sons, J., Silver and Steel Cutlery . . .

Parker and Thompson, Assortment of Tools, &c. . . .

Smith, J. J.

Turton and Sons, T. . . .

Wilkinson and Son, T., Cutlery, Tailor's-shears, &c. . . .

MINERAL MANUFACTURES COURT.

Blanchard, Works of Art in Terra-Cotta 3 and 5

Blashfield, J. M., Artistic Manufactures in Terra Cotta . 19 and 21

Browne, R., Various kinds of Tiles 14 to 18

Bucknell, Jones, and Co. .

Burgon, J. T., Patterns of Gun-flints, German and Turkey Whetstones

Doulton and Co., Stoneware Chemical Apparatus, Filters, Jars, Pipes, &c., Terra Cotta Vases . 10

Farnley Iron Co., Iron and Fire-clay Productions . . . 2

Finch, J., Patent Bricks, Tiles, and Bath-room Furniture . . 4

London and Penzance Serpentine Co., Obelisks, Monuments, Vases, Fountains, and various other Mineral Manufactures . . 9

Minton, Hollins, and Co., Tiles, in Mosaic, Encaustic, Plain Venetian, Ornamented, Moorish, and other Styles

Morgan and Rees, Implements, &c. used in the Manufacture of the Precious Metals . . .

Stevens, G. H., Glass and other Mosaic Work. . . . 20

Workman, J., Patent Brick and Cement.

HARDWARE COURT.

Adams and Sons, W. S., Victoria Regia Registered Baths, Furnishing Ironmongery . . .

Billinge, J. 25

Barlow, J., Household Utensils, &c. 22

Barringer and Co., D. C., Specimens of Moulding Sand, and Bronze Castings . . . 40A

Beverly and Son, J., Gas-Cooking-Stoves and Gas Meters. . .

Benham and Sons, Ranges, Stoves, Fenders, Gas Cooking Apparatus, Tea Urns, Lamps . . . 41

Burney and Bellamy, Iron Tanks and Cistern 40B

Chubb and Son, Patent Locks and Safes

Clarke, S., Lamps, &c., of various kinds 16

Crook, E. and F., Improved Kitchen Range, Hot-plates, &c., Wrought Iron Lily . . .

Duley and Sons, J., Patent Ranges, &c. 18

Hart and Sons, J., Patent Door Furniture, Ornamental Metal House-fittings . . 32

Hill, J. V., Mechanical Tools . . 12

Hulett and Co., D., Gas Apparatus 23

Huxham and Brown . . .

Jobson, R. 1

Kent, G., Domestic Utensils . . 14

Knight, T. and S. . . 6A

Kuper and Co., Wire Ropes and Submarine Electric Telegraph Cables

Lyon, A., Machine for Mincing, and for Manufacturing Sausages. 33

Masters, T., Various Patent Household Apparatus . . . 4

Morewood and Rogers, Galvanized Tinned Iron, and Plumbic Zinc 29 & 31

Newall and Co., Patent Wire Rope and Cord 2

Nye and Co., S., Patent Mincing Machine 7

Parnell and Puckridge, Iron Safes, Locks, Doors, &c. . . . 3

Ralph and Co., C., Articles of Furnishing Ironmongery . . . 5A

Rickets, C., Gas Ranges, Stoves, &c. 5B

Robinson, Langton, and Co., Iron and Brass Ware, Tools, &c. . 12B

Russell and Co., J., Iron Tubing . 34

Russell and Sons, J., Gas and Locomotive Tubing, Patent Lapwelded Marine and Locomotive Tubing 42

Spiller, E., Bachelor's Tea Kettle . 6B

Stocker, Bros., Patent Beer Engines, Lift-Pumps, Water Bottles, Pewter Goods, &c.

Thomas, R., Tools for various Trades 12A

Warner and Sons, J., Hydraulic Apparatus, Bells, Braziery Goods . . . 15 to 19

Wenham Lake Ice Co., Refrigerators, &c. 21

Young, W., Spirit Lamps and Vessels, Gas Burners . . . 24

Zimmermann, E. G., Iron and Zinc Bronzes 5

FURNITURE COURT.

Alderman, J., Carriages and Furniture for Invalids

Bateman, H., Specimens of Wood used in Pianoforte and Cabinetwork 22 to 24

Bayly, J. D., Paper Hangings and Oil Paintings . . . 35 to 39

Betjemann, H. J., Patent Revolving, Rocking, Combination, and Reading Chairs . . 51

Betjemann, G. S., Patent Self-Fastening Centripetal Spring Bedstead; Indispensable Chair . 50

Blyth, Son and Cooper, Bedfeathers and Horsehair, Ottoman-Chair-Bedsteads 69

Baynes and Son, Specimens of dyed and cleaned Damask and Chintz furniture 8

Box, J., Fancy Cabinet Furniture and manufactures . . . 49A

Cooke, Hindley, and Law, Velvetpile, Brussels, Kidderminster, and Berlin Carpets . . 8 and 9

Cox and Son, Ecclesiastical Furniture, Church Decorations, and Vestments . . . 40 and 41

Crace, W., Chairs, &c., in carved Rosewood and Mahogany . 10 to 12

Day, H., Illuminated lettering of the 14th century . . . 44

Filmer, T. H., Cabinet Furniture, Easy-chairs, and Decorative Upholstery . . . 31A to 33A

Greenwood, J., Models of Glass Cases, fitted with India Rubber and Wooden Stops . . . 77

Harrison, R., Tapestry Work . 49

Horne, R., Pompeian and other Panelled Decorations . . . 29

Jackson and Graham . . .

Loader, R., Household Furniture .

Lyle, J. G., Newly-invented Easy Chairs, Mattrass, &c. . . . 74

Moore, J., Patent Moveable Glass Ventilator; Patent Respirator; and Specimens of a New System of Enamelling 42

Oliver and Sons, W., Specimens of Foreign Fancy Hardwoods . 17 and 18

Reed and Marsh, Library-table . 48

Rogers, W. G., Twenty Specimens of Carving in Wood . . . 1

Smee and Sons, W., Cabinet Furniture 43A and 44A

Teale and Smith, Imitation Marquetry 46

Vokins, J. and W., Mechanical, Imitation Metal and other Frames 76

Wallis, J., Walnut Chess Table, ornamented with original paintings

Wallis, T. W., Specimens of Wood Carving 45

Wilkinson, Son and Co. . . 25 and 26

Winterbotham, A., Dacian Paperhangings, Damasks, and Calicos . 4

Ward, J., Invalid Chairs for In-door and Out-door use . . . 49B

Webb, E., Coloured Damask, Damask Hair-Cloth, Hair Carpets, &c. 3

Yates and Nightingale, Painted and Embossed Table Covers, &c. .

MIXED FABRICS COURT.

Allan and Co., M. W., Silk Mercery and Drapery Shawls . . .

Bull and Wilson, Cloths, Fancy Silks, Cashmeres, &c. . . 12

Chironnet, V., Laces, Cleaned, &c. 43B

Dick and Son, J., Sewing Cotton on Reels 43A

Elliot, M. A., Irish Tabinet or Poplin

Farmer and Rogers, India, China, and Paisley Shawls . . . 43

Faulding, Stratton, and Brough, Damask Table Linens . . 39

Groucock, Copestake, and Moore, Lace and Muslin Manufactures . 42

Jay, W. C., Mourning Furnishing Goods 45

Leach, Broadbent, Leach and Co., Woollen Stuff and Fabrics . 22

Reid, J., Printed Muslins and Drapery

Simmons, W., Millinery, Fancy Bonnets, &c.

Swears and Wells, Articles of Hosiery 23

PRINTED FABRICS COURT.

Lewis and Allenby, Manufactured Silks, and Shawls . . . 7

Simpson, J. and J., Tapestry Damask for Curtains. . . . 18

MUSICAL INSTRUMENTS COURT.

Boosey and Sons, Various Wind Instruments, Patent Drum-stick, &c. 24

Brinsmead, H., Improved Pianoforte 42

Cooper and Son, J., Michrochordon Pianoforte 38

Challen and Son, Cottage Pianoforte 43

Distin, H., Various Wind Instruments, Patent Side Drum . . 13

Greaves, E., Musical Tuning Implements 18

Hughes and Denham, Patent Grand Range Harmonichordon Pianoforte

Jones, J. C., Pianoforte . . 52

Köhler, J., Lever and other kinds of Brass Musical Instruments, of Patent Manufacture . . . 12

Levesque, Edmeades, and Co., Pianoforte 28

Marsh and Steedman, Cottage, and Michrochordon Pianoforte . 41 and 47

Moore, J. and H., a Cottage-Grand Pianoforte 35

Pain, W. G., Two Cottage Pianofortes . . . 48 and 49

Peachey, G., Albert Piccolo Pianoforte 25

Sacred Harmonic Society, Model of Orchestra as arranged for the Oratorios of the Society . . 65

Taylor, S. C., Two Concertinas .

Tolkien, H., Pianoforte . . . 46

Ventura, A. B., Various Musical Instruments, Ancient and Modern . 4

SOUTH-EASTERN CORNER OF CENTRAL TRANSEPT.

Rimmell, E., Fountain of Sydenham Crystal Palace Bouquet.

NAVE.

Atkinson, J. and E., Perfumery, Soaps, and Toilet Furniture . 9

Brown, S. R. and T., Specimens of Muslins and Laces, embroidered by Scotch and Irish Peasantry . 7

Forrest and Sons, J., Various kinds of Irish Lace and Embroidery . 12

Groux's Improved Soap Co., Household, Toilet, and Marine Soaps . 10

Hanhart, M. and N., Lithography and Chromolithography . . 3

Heath, J., Invalid Bath Chairs .

Lancashire Sewing Machine Co., Sewing Machines 5

Macdonald and Co., D. and J., Infants' Clothing 4

Meyers, B., Walking Canes and Sticks. 18

Morgan, J., Wicks, &c., in illustration of the manufacture of Candles. 8

Mechi, J. J., Dressing and Writing Cases, Cutlery, Pocket-books, &c. 2 and 17

Osler, F. and C., Crystal Glass Candelabra 6

Powell, J. H., Books and Maps, Hair Dye 16

Price's Patent Candle Co., Specimens of Candles, and of the Material manufactured; Extracts of Stearine and Oleine. . . 11

Rimmell, E., { Fountain of Eau de Cologne (S. E. End) Fountain of Toilet Vinegar (N. E. End)

Robinson, H., Writing and Dressing Cases 15

Spiers and Son, Ornamented Works in Papier Mâché . . 1

Thomas, W. F., Thomas' Patent London Sewing Machine . .

SOUTH WING.

IN OR NEAR THE REFRESHMENT DEPARTMENT.

Lipscombe and Co., Marble and Glass Fountains, &c.

NORTH WING.

DEPARTMENT FOR AGRICULTURAL IMPLEMENTS.

Barrett, Exall, and Andrews, Steam Engines, Agricultural Implements and Machinery . .

Barry, Bros., Specimens of Non-Poisonous Sheep-Dressing Composition.

Bigg, T., Dipping Apparatus for using Bigg's Patent Composition

Boulnois and Son,

Buerell, C., Portable Steam Engine, Various Farming Machines . .

Clayton, H., Various Patent Machines

Clayton, Shuttleworth, and Co., Steam Engine, Threshing Machine, Grinding-Mill . . .

Cogan and Co.,

Cottam and Hallen, . . .

Croggon and Co.,

Croskill and Son, W. . . .

Dray and Co., W.

Ferrabee, J. and H., Steam Engine, Grinding-mill, Mowing Machines, &c.

Garrett and Son, Models and drawings of Implements and Machines for Agricultural purposes

Haines, F., Shoes for Sheep, to cure Foot-rot, Foot-rot Powder . .

Hart, C., Threshing Machines, with combined apparatus for Winnowing, &c.

Hill and Smith,

Hornsby and Son, R., Portable

Steam Engine, Machines for Dressing and Drilling Corn .

Howard, J. and F., Patent Ploughs, Harrows, Horse Hoes, &c.

Huxham and Brown, Three Millstones

Lyon, A., Machines for Cutting Vegetables

M'Neill and Co., . . .

Nicholls and Co., Weighing and Chaff-cutting Machines, Scales, Weights and Measures, Corn Bruisers and Mills . . .

Pierce, W.,

Ransomes and Sims, Agricultural Machinery, Steam Engines, &c.

Smith, S.,

Smith and Ashby, Patent Haymaking, and Chaff-cutting Machines, Horse Rake, and Wheel Hand Rake, &c. . . .

Smith, W., Improved Steerage, Horse-hoes, &c. . . .

Stanley, W.,

Tournay and Co., Wheels Manufactured by Machinery worked by Steam power

Wilson, F. J., Patent Barrows .

Wilkinson, T.,

Young and Co., C. D., . . .

EAST GALLERY, ADJACENT TO CENTRAL TRANSEPT.
DEPARTMENT FOR PRECIOUS METALS.

Acheson, W., Irish Jewellery and Ornaments, Antique and Modern 86

Benson, S. S. and J. W., Jewellery, Watches, and Plate . . 1 & 2

Biden, J. and F., Process of manufacture of Gold Chains, &c., Specimens of Seal Engraving, &c. 42

Chaffers, Jun., W., Coins, Medals, and Antiquities . . . 100

Connell, Mrs. M., Irish Bog Oak Ornaments 87A

Elkington, Mason, and Co. . 103 to 106

Forrer, A., Jewellery and Fancy Work in Hair . . . 87 & 88

Gorsuch, W. H., Precious and other Stones, with a Lapidary's Table, and Illustrations of the Process. 44

Goggen, J., 68

Hawkins, F.G.S., F.L.S., B. Waterhouse, Sketch Models of the Extinct Animals, &c. . . 42A

Holt, R. W., Work in Jet, Foreign Jewellery, &c. . . 131 & 132

Jackson, W. H. and S., Chronome-

ters and Watches, with Registered Improvements . . . 100A

Keith, J., Plate, &c., for Ecclesiastical Service . . . 44A

Mahood, S., Jewellery, Bog Oak Manufactures, &c. . . . 64A

Marriott, J., Glass Apiary, Humane Cottage Beehive, with Bees at Work

Marshall, E. S., Specimens of Goldbeating 62

Meyers, M., Jewellery, and Irish Bog Oak Ornament . . 83A

Restell, R., Clocks, Watches, Plate, Jewellery, &c.

Staight, T., Manufactures in Ivory, Pearl, Tortoiseshell, &c. . 46

Steinitz, Bros., Parquetose Flooring, Ivory Carved, Wood Mosaic.

Vieyres and Repingon, An Astronomical Clock . . . 100B

Watherston and Brogden, Gold Chains and Miscellaneous Jewellery 101 & 102

Waterhouse and Co., Ancient and Modern Irish Jewellery . 65 & 66

SOUTH-EASTERN GALLERY.
DEPARTMENT FOR SUBSTANCES USED AS FOOD.

Batty and Co., Pickles, Preserves, Sauces, and Oilmen's Stores . 15 & 16

Dunn and Hewett, Cocoa, Coffee, Extracts and Spices . . . 6

Edwards, Bros, Preparations of Farinaceous and other Food . . 12

Fry and Sons, Cocoa, its Varieties of Growth and Manufacture . 17

Glass, G. M., Isinglass, Gelatine Lozenges, and Jujubes . . 12B

Gunter, R., Bride Cakes and Confectionery 20

Horniman and Co., Tea as Imported free from Artificial Colouring . 10

Kent and Sons, Bordeaux Wine Vinegar 12A

Lea and Perrins, Sauces, Chemical Drinks, &c. 18

Paris Chocolate Co., Cocoa and its various manufactures . . .

Phillips and Co. Tea and Coffee in all their various kinds . . 11

Slee, T. P. and C. B., Mustard in the Seed and Manufactured. Blue for Laundry purposes . . . 6A

Turner, G., Wedding and other Cakes 9

Vickers, J., Russian Isinglass in Shapes 18A

White, G. B., Cocoa, and Chocolate in their various stages of preparation

DEPARTMENT FOR MISCELLANEOUS ARTICLES.

Austin, J., Patent Line . . .

Cave, A., Fancy Articles, Workboxes, &c. 14

Davis, Mrs. Cigars and Tobacconists' Goods in General . . 12A

Davis, J. J., Seal Engraving, Copying and Embossing Presses . 16

Farlow, C., Fishing Tackle . . 12

Inderwick, J., Fancy Goods, more particularly in connection with Smoking, Tobaccos, &c. . . 21 & 22

Jones, B. C., Cigars of every description 1 & 2

Kite, J., Patent Ventilating and Smoke Curing Apparatus, illustrated by experiment . . . 3A

Latour, Rateau and Co., Dyed and Cleaned Goods 7

Lillywhite, Bros., Articles connected with the Game of Cricket 9

Marsland, Sons, and Co., Fancy Work and Cotton. . . . 5 & 6

Muggleton, W. H., Linen Stamps, Marking Ink, &c. . . . 4

Nixey, W. G. Patent Revolving Till, Blacklead, &c., Dyes, Varnishes, &c. 10

Phillips and Co., Pipes, Stems, and Cigar Tubes 17

Rymer, S. L. 4A

DEPARTMENT FOR FINE LINENS AND DAMASKS.

Hollins, E., Patent Shirting . .

Russell, H. and G., Specimens of

Sail Cloth of English and American manufacture . . .

SOUTH GALLERY.

DEPARTMENT FOR CLOTHING.

Asser, L., Ladies' and Children's Ready-made Clothing and Outfits. 28

Berni and Meillard, Velvet and Beaver Hats of all descriptions . 4

Brook, Bros., J. 39 & 40

Caplin, Mme. R. A., Medical Corsets, Belts, Supports for Invalids, &c. 8

Capper and Waters, Shirts of various fashions 12 & 14

Carrol, Bridget, Various Articles of Dress in Lace

Carter and Houston, various Kinds of Improved Corsets . . . 38

Coles, W. F. Newly Invented Socks, of various kinds . . 16A

Cooper and Fryer, the Gorget Patent Shirt, Elliptic Collars, &c. .

Daily and Co., Specimens of Dyeing and Cleaning Silks, &c. . . 5

Dando, Sons, and Co., Hats and Caps Manufactured for lightness 16

Davies, J., Fashionable Riding Habit 36A

Eason, J., Ready-made Linen, French flowers, &c. . . 24 to 26

Ellwood and Sons, J., Air-Chamber Hats, &c., for Warm Climates 34

Gaimes, Sanders, and Nicol, Patent Hats . . . 19 & 20

Glenny, C., Balbriggan Cotton Hosiery 10A

Grundy, T., Easy Boots of a New and Improved Manufacture . 32

Hawkins, Mrs., Corsets and Belts . 32A

Hayward and Co., Embroidered Cloth, Silk, Berlin Cloth, &c. . 32B

King and Co., W., Silks, Satins, Velvets, Woollen Manufactures, Cambrics, Linen, Haberdashery, &c. 2

Marion and Maitland, Corsets, Medical Supports, &c. . . 36

Nicoll, B., Specimen Shirts . 18A

Nicoll, H. J. and D., Specimens of the Fashion, Patented and Registered Articles of Dress and Personal use . . . 17 & 18

Paine, H. and Co., Trousers . .
Philps and Son, Ladies and Chil-
dren's Clothing and Hosiery 25A & 26A
Price and Co., Waterproof and Air-
proof Goods
Rumble, Mrs., Surgical Bandages,
Supports, &c.
Smith, Mrs. J., Corsets and Socco-
pedes, Elastic or Silk Boots .
Smith, Julia, Corsets . . . 35A
Stroud, M. and D., Articles of Ho-
siery, &c. 6
Stuart, J. K., Patent Ventilating
Hats 35B

Thompson, Miss S. C., Widows' Caps 8A
Thresher and Glenny, Under-cloth-
ing for Warm Climates, Notting-
ham Hosiery 10
Upton and Co., W., Specimens of
English and Foreign Leathers,
and Leather Mercery . . . 30
Watkins, W., Military and other
Clothing 1
Whitelock and Son, Articles of
Hosiery 41
Williams and Son, R., Umbrellas,
Parasols, Whips, Canes, &c. 21 & 22
Wright, E. J., Corsets, &c. . . 35

SOUTH END OF BUILDING.

DEPARTMENT FOR STAINED GLASS, &c.

Nosotti, C., Large Looking Glass in
Solid Carved Florentine Style of
Frame

Waites, W., Three Stained Glass
Windows

SOUTH-WESTERN GALLERY.

DEPARTMENT FOR MISCELLANEOUS ARTICLES.

Allaire, René, Specimens of Dyeing
and Cleaning. 34A
Barnett, B., Specimen of Old Paint-
ing Restored
Bartlett, J., Patent Compressed
Cricket Bats 36A
Burningham, C., Assortment of
Goods in Papier Mâché . . 47
Carles, H. R., Gentlemen's Head-
dresses and Perukes . . . 32
Child, W. H., Specimens Brushes
manufactured in Ivory, Bone,
Tortoiseshell, and Wood . .
Collings, J., Tailor's Registered
Arm-pad 39
Cowvan, B. and S., The Canton, or
Quadrilateral Strop . . . 38
Cullingford, W., Various kinds of
Netting 53A
Curtis and Son, M. I., Pianoforte-
strings, Wire-screws and Pins .
Dillon, A., Specimens of Orna-
mental Writing
Farley, H., Models of Naval Archi-
tecture and Implements . .
Foot, Mary, Artificial Flowers,
Head-dresses, &c. . . . 49
Freckingham, Mrs. E. Specimens
of Fancy Work 37
Giles, J. A., Specimens of Portrait
Painting 56
Gittens and Allkins, Patent Detec-
tor Tills and Base Coin Detectors 37A
Grujeon, A., Cases of Plants, ar-
ranged in Botanical Order . . 39A
Hack, R., Harmonicon and Flute
Flageolet 30
Helfrick, F., An Invention to Navi-
gate the Air 29A
Hodges and Turner, Various kinds
of Elastic Fabrics. . . . 31A

Holliday, R., Self-generating Gas
Lamps, Chemicals, &c. . . 31
Hyams, M., Cigars, Tobacco, and
Illustrations of their Manufac-
ture 29
Jackson, W., Wirework Mountings
for Whips, &c. 72
Joyce, F., Percussion Gun-caps,
Primers, Waddings, &c. . . 27B
Judson and Son, D. Dyewoods and
General Drysalteries . .
Lee, Thomas, Waterproof and Air-
proof Goods 28A
Levin, L., Glass Beads, Real and
Artificial Coral, &c. . . . 32A
Loysel, M., Newly-invented Ma-
chines for Making Coffee . 41 & 42
Maynard, J., Wire, &c., used in the
Manufacture of Pianofortes . 36
Mead and Powell, Toys, &c., Fancy
Cabinet Work . . 43 & 44
Noden, J., Hair-Dye, with Speci-
mens of its Application . . 49B
Olin, L., Purses made by Machi-
nery
Parker, J., Stag's-horn Umbrella
Stand 47A
Pierotti, H., Wax Dolls and Figures
for Hairdressers 40A
Ralph and Son, Articles of Gentle-
men's Fashionable Dress .
Ramage, R., Fair's Patent Venti-
lators 39B
Read, T., Specimens of Ornamental
Writings, Embossing, Household
Decoration, and Lithography . 27A
Revell, J., Ornamental Leather-
work, and Implements, and
Materials used 38A
Riddell and Co., W., (Anglo-Conti-
nental Co.)

Roe, F., Models of Fountains, Jets d'Eau, Valves, &c. . . .

Salmon, I. 35A

Samuel, M., Foreign Shells, Corals, and China 53

Sanders, W., Modelling in Leather 32B

Sangster, W. J., Parasols, Umbrellas, &c., of various kinds 34

Saunders, J., Specimens of Teas and Coffees 40

Saunders, R., Fast-dyed Woollen Goods and Dye Detector . .

Walden, H., Variegated Linen-Baskets 55

DEPARTMENT FOR PERFUMERY.

Eason, R., Hair Perfumery, Combs and Brushes

Higgins, J., Distilled Essences for Perfumes 6

Lewis, J., Perfumes, Soaps, and Toilet Furniture . . .

Saulson, M., Soaps, Essences, Pomatums, &c. 5

Sturrock and Sons, Perfumery, and Toilet Furniture . 3 & 4

DEPARTMENT FOR CHEMICALS.

Allshorn, F., Homœopathic Medicine Chest, Medicines, Works, &c. 4A

Andrew, F. W., Cemented China and Glass, Articles of Toilet Furniture 6

Blundell, Spence, and Co., Assortment of Painter's Colours . . 5A

Burton and Garraway, Cudbear, Orchil, and Indigo Dyes . 4

Electric Power Light and Colour Co., Electric Colours . . . 2A

Field, J. C. Specimens of Wax, Candles, Sealing Wax, &c. 7

Gibbs, D. and W., Fancy and other Soaps 1A

Jones and Co., Orlando, Specimens of Starch from Rice . . . 3

King, W. W., Effervescent Citrate of Magnesia 4B

Prockter, Bevington, and Prockter, Inodorous Glue . . . 6A

Rottmann and Co., G., Sodawater Machines and Filters . . .

Reeves and Sons, Artists' Water Colours and Implements . . 5

Rose, W. A., Oil and Grease, for Burning and Machinery, Varnishes, Paints, &c. . . . 8

Walker and Stembridge, Gums, Glues, Dyes, and Chemicals .

Williams and Fletcher, Colours and Chemicals

DEPARTMENT FOR LEATHER.

Blackwell, S., Assortment of Saddlery and Harness, patent and otherwise 40

Brown, J., India Rubber Beds, Sofas, Chairs, and Marine Spring Bed

Cant and Sons, G. W., Ladies and Gentlemen's Boots and Shoes of all kinds 14

Clarke, C. and J., Manufactures from the Angora and Sheep Skin, Boots, Shoes, and Slippers 21 and 22

Davis, Mrs. A., Saddlery, Harness, and Horse Clothing . . . 12

Deed, J. S., Morocco Leathers of Various Kinds, Dyed Sheep and Lamb's-wool Rugs . . . 24

East and Son, T., Specimens of Leather and Manufactures from the Skin of the Sheep . . 4

Ford, A. F., Boots and Shoes . 23

Gutta Percha Co., the West Ham, Articles manufactured in Gutta Percha, under Letters Patent .

Gottung, J. B., Two sets of Harness, worked with Peacock-quills; Covers and Mats of Peacock-work 19

Hall, J. S., Models of Boots manufactured for the Royal Family and Nobility . . . 10

Haines and Nobes, Mill-bands and other Articles of Leather Manufacture 26

Hall and Co., Leather-Cloth Boots and Shoes, Goloshes, &c. . 20

Jeffs, R., Furs of the Arctic and Cold climates . . . 6

Jones and Waters, Fancy Leathers used in the Manufacture of Hats, Caps, &c. 28

Marsden, C., Ventilating Boots, Shoes, Goloshes, &c. 37 & 38

Maxwell and Co., H., Spurs and Sockets 10A

Newton, T., Harness and Horse appointments generally .

Norman, J. W., Boots and Shoes, &c. 28A

Oastler and Palmer, Specimens of Tanned Skins . . 34 & 36

Preller, C. A., Patent Leather Machine Bands, &c. . . 18

Roberts, E. B., Manufactures from the Beaver, and various other Skins 8

Swaine and Adeney, Whips and
Riding Canes of all kinds . . 32
Southgate, G., Solid Leather Port–
manteaus 16A
Urch, H., Saddlery . . . 6A
Wansbrough, J., Garments Manu-
factured from the Patent Para-
India Rubber Cloth . . . 39

Watson, C. J., Utilis Portman-
teau 30A
White, J. C., Harness, with White
Patent Tugs 16
Wilson, Walkden, and Co., Pre-
pared Sheep Leather . . . 35A
Wright, R., Patent Boots and
Shoes

DEPARTMENT FOR INDIA-RUBBER.

Edmiston and Son, India Rubber
Clothing, Ornamental Objects,
in Gutta Percha and India
Rubber 19 & 20
Goodyear, C., Articles Manufac-
tured from India-Rubber . . 1 to 12

Grueber and Co., Patent Asphalte
Sheathing and Dry Hair Felt .
Mackintosh and Co., India-Rubber,
native, and manufactured,
with illustrations of the pro-
cess 13 to 18

WEST GALLERY, ADJACENT TO CENTRAL TRANSEPT.

DEPARTMENT FOR PHILOSOPHICAL INSTRUMENTS.

Bailey, W. H., Medical Instru-
ments, Invalid Supports, &c. . 87
Beard, Jun., R., Daguerreotype
and Photographic Pictures. Ste-
reoscopes, &c. . . . 33 & 34
Bermingham, Esq., T., Maps,
Plans, &c. 48A
Caplin, M.D., J., Medical Gymnasia,
Instruments, and Furniture for
the Cure of Deformities . . 47A
Claudet, A., Daguerreotype and
Stereoscopic Portraits .
Coles, W., Patent Trusses .
Colt, Colonel S., Patent Repeating
Firearms . . . 91 & 92
Cronmire, J., M. and H., Mathe-
matical and Nautical Instru-
ments 60
Deane, Adams and Deane, Fire
Arms
Elliott, Bros., Optical, Mathemati-
cal, and Philosophical Instru-
ments 29
Elliot, J., Daguerreotype and Ste-
reoscopic Portraits . . . 40
Grossmith, W. R., Artificial Eyes,
Limbs, and other Productions of
Surgical Mechanism . . . 27
Harnett, W., Dentistry and Articles
used in Dental Surgery .
Hennah and Kent, Photographs . 49
Hobson, T. 38A
Hogg, R., Photographic Portraits,
Landscapes, &c. . . . 40A
Horne, Thornthwaite, and Wood,

Photographic Cameras, &c.,
Pictures, Medical Electro-Gal-
vanic Machine . . . 48
Laroche, M., Photographic Pic-
tures
Mayall, J. E., Photographic Pic-
tures 31
Miles, E., Artificial and Mineral
Teeth, Gums, and Palates . . 37
Newson, H., Patent Wire Trusses 49A
Novra, G., Cutlery, Articles in
Electrotype 11
Pottinger, C. R., Photographic
Apparatus, Stereoscopes, &c. 1 & 2
Potter, J. D., Scientific and Philo-
sophical Instruments . . 58A
Prince and Co., Models of Inven-
tions
Read, R., Agricultural and Hor-
ticultural Machines, Surgical
Instruments, &c. . . . 41
Reid, W., Instruments and manu-
factures in connection with the
Electric Telegraph . . . 47
Smith H., Trusses, Medical Sup-
ports, &c.
Statham, W. E., Philosophical
Instruments in connection with
Chemistry 58
Stidolph, W., Educational Instru-
ments for the Blind . . . 38
Sharpe, T., Photographic Portraits 50
White, J., Patent Trusses, Belts,
Surgical Supports, &c. . . 30

DEPARTMENT FOR PRINTED BOOKS, ETC.

Kent, W., Printed Books . .

Tweedie, W., Temperance Books
and Publications . . .

NORTH-EASTERN GALLERY.

DEPARTMENT FOR CHINA AND GLASS.

Aire and Calder Bottle Co., Specimens of Glass Bottle Manufacture 33 & 34

Bourne and Son, Patent Stone-Ware Bottles, Jars, Vases, &c. . 15

Brace and Colt, Manufactures of the "Serpentine" stone . .

Clarke, Miss C., Antique China, Point Lace, &c. . . . 65 & 66

Claudet and Houghton, Glass Shades and Photographic Glasses

Copeland and Son

Goode and Co., T., China, Glass, China Lace Figures, imitation Majolica Ware 6

Green, J., Useful and Ornamental China, Glass, and Earthenware. 37 to 40

Hetley, H., Glass Shades and Cases 28

Hetley and Co., J., Glass-shades Window and Horticultural Glass 36

Kerr, Binns, and Co. . . . 41

Litchfield, S., Ancient Furniture, China, Clocks, Candelabra, Bronzes, &c.

Lockhead and Co., J., Patent Perforated Glass, Specimens of Glass, and Glass Manufactures . 13

Roberts, J., Patent Invention for Cooling Drinks and Edible Matters; Specimens of Terra Ferrum 10

Sinclair, C., Glass and China . 11A & 12A

BASEMENT.

DEPARTMENT FOR MACHINERY.

Beecroft Butler and Co. . . .

Bellhouse and Co., E. T. . . .

Bernard, J.

Birmingham Patent Iron and Brass Tube Company . . .

Bradbury and Evans

Burch, E. J.

Calvert, F. C.

Collins, H. H.

Coltman, W.

Condie, J.

Dalgetty, Ledger, and Co. . . .

Dering, G. E.

Dunn, Hattersly and Co. . . .

Galloway, W. and J. . . .

Gent and Co., G.

Goodall, H.

Goodfellow, B.

Grout, J.

Hanson and Chadwick . . .

Harrison and Sons, J. . . .

Hill, W.

Hughes and Denham . . .

Hughes, R. and T. . . .

Lister and Co. A.

Lloyd, Jun., G. B. . . .

Lloyd, G.

Lomas, Fromings, and Sykes . .

Muir, G. W.

Mansell, T.

Mason, J.

Manlove and Alliott

Moseley and Co., J. . . .

Onions, J. C.

Percy, W. C. S.

Piper and Co.

Preston, F.

Quick, J. V.

Ramsbotham, J.

Reade, Spencer, and Co. . . .

Renshaw, G. P.

Robinson and Co., H. O. . .

Richmond, S.

Samuelson and Co. M. . . .

Shand and Mason . . .

Smith, B. and J. . . .

Snowden, F. W.

Taylor, T.

Walker and Hacking . . .

Walsh and Co., A. J. . . .

Warner and Sons . . .

Whitworth and Co. . . .

Wright and Co.

Williams, W.

DEPARTMENT FOR CARRIAGES.

Corben and Sons, Carriage upon improved principles . . .

Hedges, W., Patent Curriculum .

Hoadley, A. and S., A Carriage of First-class Manufacture . .

Holmes, H. and A., Two Improved Four-wheeled Carriages . .

Kinder and Co., Light Dog-Cart Phaeton

Kesterton, E., A Dog-Cart of Improved Construction, with Patent Shaft, &c.

Lenny, C., Carriage of the latest Plan

Mason, W. H.

Meaden, M., Four-wheeled Carriage

Offord and Co., R., A Carriage .

Starey, T. R., Cottage Dog-Cart .

Thrupp and Co., C. J., A Four-Wheeled Carriage . . .

Tudor, W. H., Barouche, Park Phaeton.

EXHIBITORS NOT CLASSED.

Boorer, R., Slate Tables in imitation of various Marbles . .
Cross and Co., J. W., Pails and Patent Fire Engines . . .
Camolera, M. de, Specimens of Flower Painting on Porcelain .
Kennard and Co., R. W., Cast Iron Gates and Railing made for the Peruvian Government. Vases and Ornamental Castings. The Cast Iron Garden Chairs in the Grounds
McCrea, H.

Merryweather, M., Fire Escapes, Fire Engines, and Implements .
Stewards and Co., Statue in Portland Stone
Taylor, Mrs. A. M. N., Various Specimens of Sea Weed . .
Wood and Jerry, Carved and Engraved Shells
Wilson, J., Statuette in Parian Marble
Wilkinson, Letitia, a Churn on Stand

BRADBURY AND EVANS, PRINTERS WHITEFRIARS.

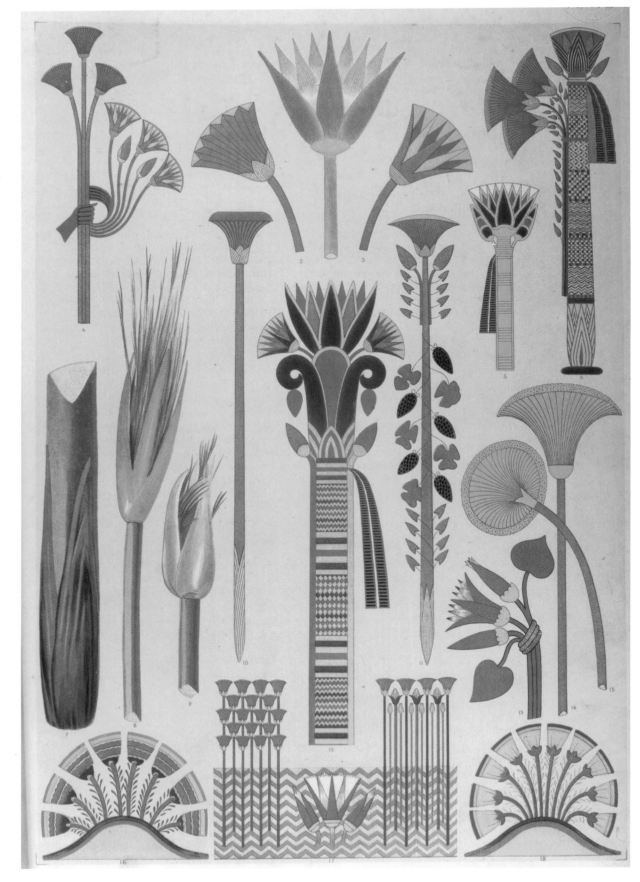

Egyptian ornament from Owen Jones's *The Grammar of Ornament*, 1856.

The Delamotte Collection
Explanatory Note

All 47 of the new Delamotte images purchased by English Heritage in 2004 have been reproduced in this book. They can be identified by caption reference number: the set of original prints have been digitally copied as DP004601 – DP004647. The original loose sepia prints vary a little in quality and size [mostly 9 × 7 inches] and are enclosed in a portfolio titled 'Delamotte. Crystal Palace at Sydenham'. The albumen prints are on mounts [19 x 14 inches] each with printed credits to the photographer, P H Delamotte FSA, the printers, Negretti and Zambra, and the Crystal Palace Art Union. There is no evidence, however, that the set as a whole was ever published or distributed. The prints must derive from now lost glass wet-plate collodion negatives. The portfolio came with a modern caption list: this list seems authentic enough though it is clearly a modern typewritten copy from a now missing original. In the absence of further evidence it would appear likely that the set formed part of a presentation set [possibly of 60 photographs] which may have been created for one or all of the directors of the Crystal Palace Company – possibly even for Sir Joseph Paxton himself. Only about 12 of these views are known to exist elsewhere: some were used as prizes for the Crystal Palace Art Union and a similar number have subsequently appeared under the name of the commercial photographer Francis Frith.

It should be carefully noted that not a single photograph from this set overlaps with any of the 160 in the set of Crystal Palace images taken by Delamotte and published in 1855, which are well known [see bibliography]. These early images have not been referred to in detail in this book since they do not show the palace in use. This famous set shows mainly the construction or progress of the palace – only one or two appear to show the finished interior after the 1854 opening ceremony. Thus the 'new' set owned by English Heritage must have been taken between 1854 and the early 1860s. Evidence, discussed in the text, suggests that the best estimate for the date taken would be between 1856 and 1859 – and certainly before the 1866 fire. Many records relating to the Crystal Palace were destroyed in 1936 and records relating to Negretti and Zambra were lost during the Second World War; English Heritage would be grateful to know of any new evidence which would help in explaining the Delamotte photographs reproduced here.

All the English Heritage Delamotte prints can be accessed online via
http://viewfinder.english-heritage.org.uk

PLATE LXX

Middle Ages ornament
*f*rom Owen Jones's *The Grammar of Ornament*, 1856.

Acknowledgements

For financial support for the acquisition of the Delamotte collection English Heritage would like to thank the Crystal Palace Foundation and the London Development Agency.

English Heritage is most grateful to Mrs Alma Howarth-Loomes for her help in making available the frames from stereo images collected by her late husband Bernard Howarth-Loomes. Thanks for granting permission to reproduce images are also due to the Crystal Palace Museum, Christie's, the Institution of Civil Engineers, the Royal Institute of British Architects and the National Portrait Gallery.

Without the help of the following experts on the Crystal Palace we would have little idea of what once existed: Melvyn Harrison, Crystal Palace Foundation; Ken Kiss, Crystal Palace Museum; and above all, Jan Piggott.

For help in finding images and reading the text thanks are given to Michael Pritchard, Christie's; Mike Chrimes, Institution of Civil Engineers; Roger Taylor; Anthony Hamber; Bernard Nurse, Society of Antiquaries; and Peter Hingley, Royal Astronomical Society.

At English Heritage thanks are due to Adèle Campbell, Nigel Clubb, Mike Evans, John Greenacombe, Val Horsler, Cynthia Howell, Edward Impey, Irene Peacock, Alyson Rogers, Tony Rumsey, Andrew Sargent and Ian Savage.

For detailed comment only Tesni Daniel could connect.

Picture Credits

All images are the copyright of the National Monuments Record, English Heritage, except as follows:

Christie's: 28; Crystal Palace Museum: 6, back cover; Hulton-Deutsch/Corbis: 34; Institution of Civil Engineers: 26, 27; James and Patricia Ritzenberg, Washington USA: 18; Michael Evans: 10; Royal Institute of British Architects: 9; Royal Astronomical Society: 50, 51; RPS/NMPFT/Science & Society Picture Library: 24; Time-Life Pictures/Getty Images: 35.

Every effort has been made to trace copyright holders and we apologise in advance for any unintentional omissions or errors, which we would be pleased to correct in any subsequent edition of the book.

Bibliography

Auerbach, J A 1999 *The Great Exhibition of 1851: A Nation on Display*. New Haven, London: Yale University Press

Anon 1857 *Description of the Mammoth Tree from California, now erected at the Crystal Palace, Sydenham*. London: R S Francis

Architectural Review **81** 1937 (Jan–Feb): Marginalia (from many architects); also articles by P Morton Shand, J M Richards and Le Corbusier

Baldwin, G (ed) 2004 *All the Mighty World: The Photographs of Roger Fenton, 1852–1860* (includes essays by G Baldwin, M Daniel, S Greenough, R Pare, P Roberts and R Taylor). New Haven and London: Yale University Press .

Banham, M and Hillier, B (eds) 1976 *A Tonic to the Nation: The Festival of Britain 1951*. London: Thames and Hudson

Bertram and Co 1891 *Facts about the Crystal Palace presented by Bertram & Co, Refreshment Contractors*. London: Charles Dickens and Evans/Crystal Palace Press

Betjeman, J 1965 'Conservatories and other Edwardiana: An exercise in nostalgia by John Betjeman and Osbert Sitwell'. *The Listener* (4 Jan 1965), 194–5

British Journal of Photography, 15 June 1863, 261; 15 July 1863, 295; 3 October 1879, 472 (obituary)

Chadwick, G F 1961 *The Works of Sir Joseph Paxton, 1803–1865*. London: Architectural Press

Chrimes, M 1991 *Civil Engineering, 1839–1889: A Photographic History*. Stroud: Alan Sutton

Colquhoun, K 2003 *A Thing in Disguise: The Visionary Life of Joseph Paxton*. London: Fourth Estate

Crinson, M 1996 *Empire Building: Orientalism and Victorian Architecture*. London: Routledge

Delamotte, P H 1855 *Photographic Views of the Progress of the Crystal Palace, Sydenham*. London

Delamotte, P H 1853 *The Practice of Photography: A Manual for Students and Amateurs*. London: Joseph Cundall

De Mare, E 1973 *London 1851: The Year of the Great Exhibition*. London: Folio Society

Flukinger, R 1978 *Paul Martin, Victorian Photographer*. London: Gordon Frasier Gallery

Friemert, C 1984 *Die Glaserne Arche: Kristallpalast London 1851 und 1854* (complete modern reproduction of Delamotte 1855). Dresden: VEB Verlag der Kunst

Francis Frith Collection www.francisfrith.com. The following Frith images are by Delamotte: 977, 978, 981, 983, 990, 1010, 1013, 1023 (some are renumbered as C207977, C207978 etc)

George Eastman House 2004 'Mother of the Forest' stereograph by E and H T Anthony www.geh.org/fm/st05/htmlsrc/m197914840004_ful.html

Hamber, A 1996 *A Higher Branch of the Art: Photographing the Fine Arts in England, 1839–1880*. Amsterdam: Gordon and Breach

Haworth-Booth, M and McCauley, A 1998 *The Museum and the Photograph: Collecting Photography at the Victoria and Albert Museum, 1853–1900*. Williamstown, Massachusetts: Sterling and Francine Clark Art Institute

Herbert, G 1978 *Pioneers of Prefabrication: The British Contribution in the Nineteenth Century*. Baltimore: Johns Hopkins University Press

Hyde, R 1988 *Panoramania: The Art and Entertainment of the 'All-Embracing' View*. London: Trefoil/Barbican Art Gallery

Jones, O 1854 *The Alhambra Court in the Crystal Palace*. London: Crystal Palace Library

Jones, O 1854 *The Greek Court erected in the Crystal Palace ... described by George Scharf, Jun*. London: Crystal Palace Library

Jones, O 1854 *An Apology for the Colouring of the Greek Court in the Crystal Palace with Arguments by G H Lewes and W Watkiss Lloyd. And a Fragment on the Origin of Polychromy by Professor Semper*. London: Crystal Palace Library

Jones, Owen 1854 *The Roman Court (Including the Antique Sculpture in the Nave) erected in the Crystal Palace described by George Scharf, Jun.* London: Crystal Palace Library

Jones, O 1856 *The Grammar of Ornament.* London: Francis Bedford

Jones, O and Bonomi, J 1854 *Description of the Egyptian Court erected in the Crystal Palace with a historical notice of the monuments of Egpyt by Samuel Sharpe, Esq.* London: Crystal Palace Library

Layard, A H 1854 *The Nineveh Court in the Crystal Palace.* London: Crystal Palace Library

Leith, I 2001 'Amateurs, antiquaries and tradesmen: a context for photographic history in London'. *London Topographical Record* **28**, 91–117

McCauley, E A 1994 *Industrial Madness: Commercial Photography in Paris, 1848–1871.* New Haven, London: Yale University Press

Negretti and Zambra 1950 *Negretti and Zambra Centenary, 1850–1950: An Illustrated Record since the Firm's Foundation.* London: Negretti and Zambra

Negretti, P A 1984 'Henry Negretti – gentleman and photographic pioneer'. *The Photographic Collector* **5**, 96–105

Owen, R 1854 *Geology and Inhabitants of the Ancient World.* With a plan by P H Delamotte of 'Extinct Animals constructed by B W Hawkins'. London: Crystal Palace Library

Parr, M and Badger, G 2004 *The Photobook: A History, Volume 1.* London: Phaidon

PhotoLondon 2005 Database of Nineteenth Century London Photographers: www.photolondon.org.uk (Extensive entry for Negretti and entries for several of his staff, George Collings and George Restall)

Phillips, S 1854 *Guide to the Crystal Palace and Park.* Illustrated by P H Delamotte. London: Crystal Palace Library

Piggott, J 2004 *Palace of the People: The Crystal Palace at Sydenham, 1854–1936.* London: C Hurst

Ruskin, J 1854 *The Opening of the Crystal Palace Considered in Some of its Relations to the Prospects of Art.* London: Smith, Elder

Samuel, R 1994–8 *Theatres of Memory* (2 vols). London: Verso

Sassoon, J 2004 'Photographic materiality in the age of digital reproduction' *in* Edwards, E and Hart, J (eds) *Photographs Objects Histories: On the Materiality of Images.* London: Routledge

Seiberling, G and Bloore, C 1986 *Amateurs, Photography and the Mid-Victorian Imagination.* Chicago, London: Chicago University Press

Stirling, A J 1990 'Philip Henry Delamotte: artist and photographer'. *RSA Journal* **138** (June 1990)

Taine, H 1957 *Taine's Notes on England* (trans E Hyams). London: Thames and Hudson

Taylor, R 2002 *Lewis Carroll, Photographer.* Princeton, Chichester: Princeton University Press

Taylor, R Photographic Exhibitions in Britain 1839–1865: www.peib.org.uk

Thompson, P 1966 'Paxton and the dilemma of nineteenth-century architecture'. *The Listener* (7 July 1966), 14–16

Thorne, R 1984 'Crystal exemplar'. *Architectural Review* (July 1984), 49–53

Thorne, R 1987 'Paxton and prefabrication'. *Architectural Design*, Profile 70, Engineering and Architecture, 23–8

University of Maryland Libraries 2004 www.lib.umd.edu/ARCH/exhibition/home.html

Wyatt, M D 1854 *Views of the Crystal Palace and Park, Sydenham from drawings by eminent artists, and photographs by P H Delamotte.* London: Day and Son

English Heritage 2004 http://viewfinder.english-heritage.org.uk to see the full set of Delamotte's photographs

Index

Illustrations are denoted by page numbers in **bold**

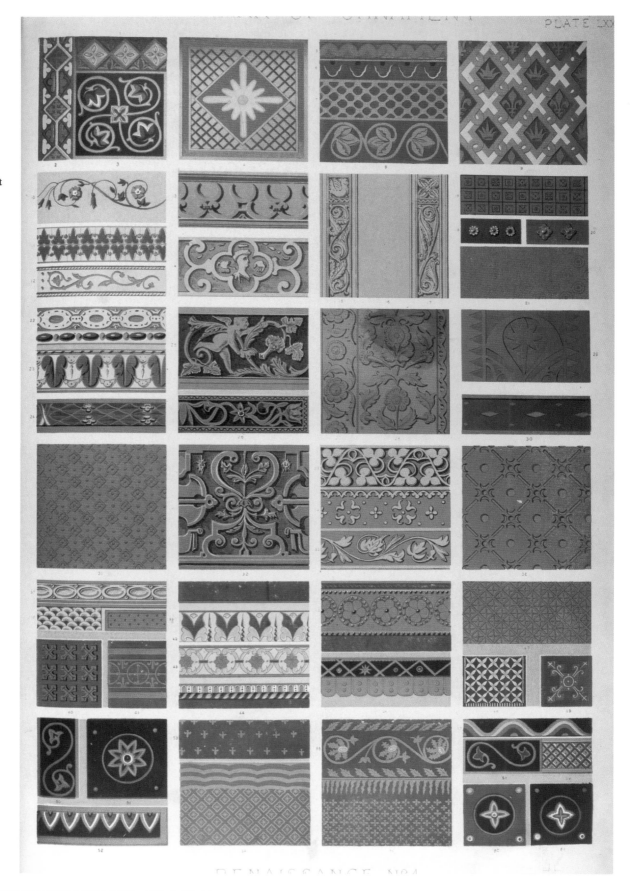

Renaissance ornament
from Owen Jones's
The Grammar of
Ornament, *1856.*